PALM BEACH COUNTY LIBRARY SYSTEM 3650 Summit Boulevard West Palm Beach, FL 33406-4198

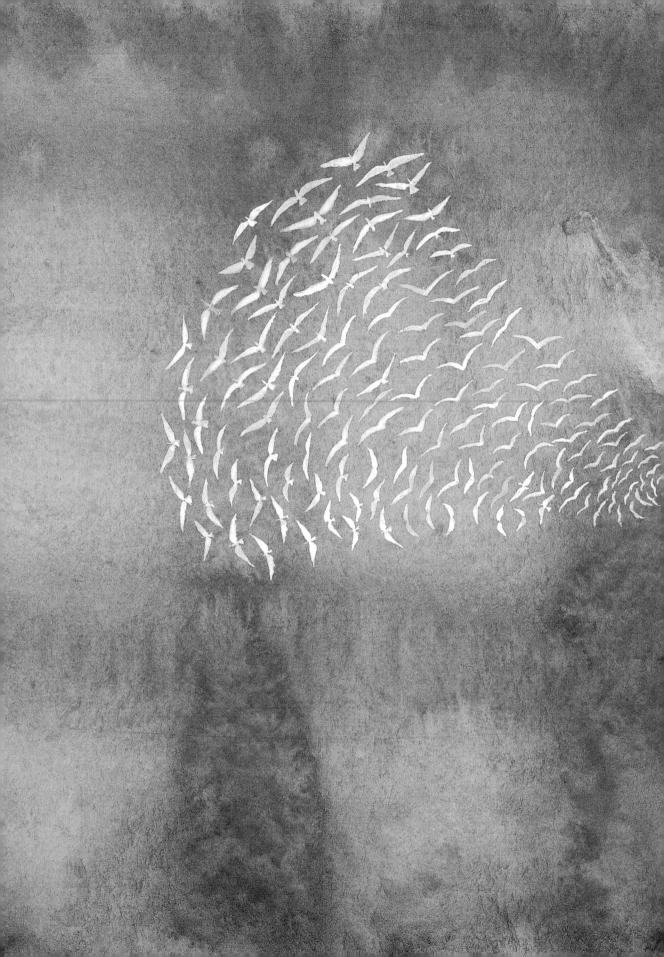

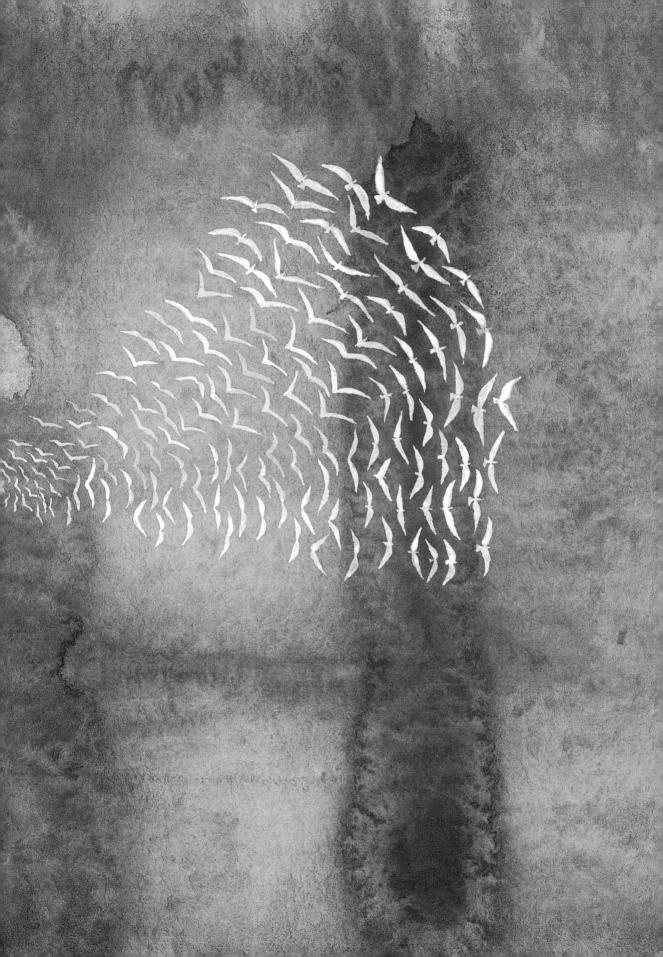

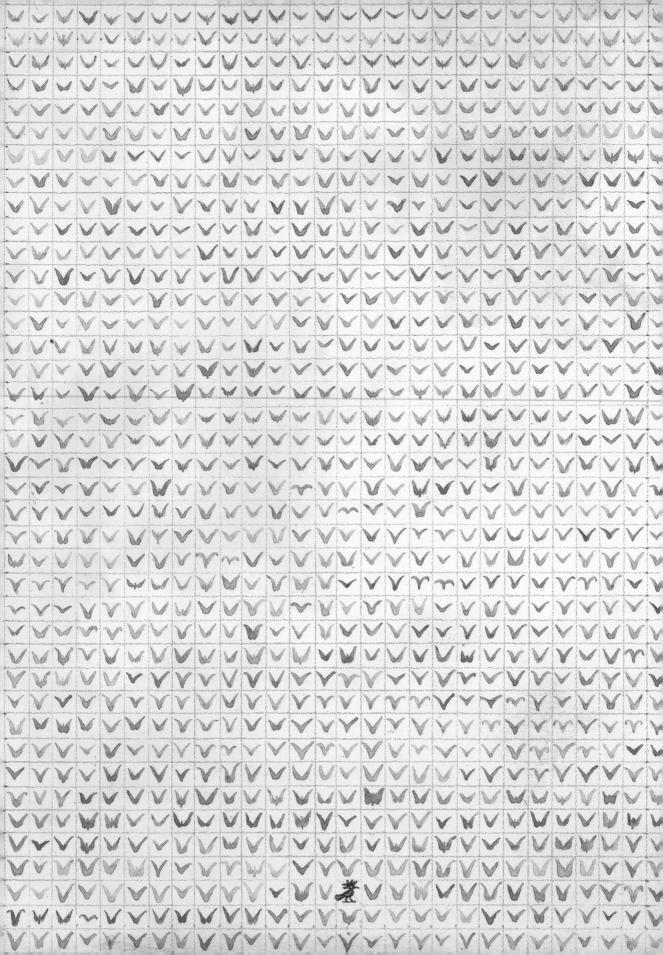

Peter Sís

THE PENGUIN PRESS

New York . 2011

THE PENGUIN PRESS

Published by the Penguin Group
Penguin Group (USA) Inc., 375 Hudson Street, New York,
New York 10014, U.S.A. · Penguin Group (Canada), 90 Eglinton Avenue East,
Suite 700, Toronto, Ontario, Canada M4P 2Y3 (a division of Pearson Penguin
Canada Inc.) · Penguin Books Ltd, 80 Strand, London WC2R 0RL,
England · Penguin Ireland, 25 St. Stephen's Green, Dublin 2, Ireland
(a division of Penguin Books Ltd) · Penguin Books Australia Ltd,
250 Camberwell Road, Camberwell, Victoria 3124, Australia (a division
of Pearson Australia Group Pty Ltd) · Penguin Books India Pvt Ltd,
11 Community Centre, Panchsheel Park, New Delhi – 110 017, India
Penguin Group (NZ), 67 Apollo Drive, Rosedale, Auckland 0632,
New Zealand (a division of Pearson New Zealand Ltd) · Penguin
Books (South Africa) (Pty) Ltd, 24 Sturdee Avenue,

Rosebank, Johannesburg 2196, South Africa

Penguin Books Ltd, Registered Offices: 80 Strand, London WC2R 0RL, England

First published in 2011 by The Penguin Press, a member of Penguin Group (USA) Inc.

1 3 5 7 9 10 8 6 4 2 Copyright © Peter Sis, 2011 All rights reserved

Page 159 constitutes an extension of this copyright page.

ISBN 978-1-59420-306-0

Art Direction and Book Design by Claire Naylon Vaccaro

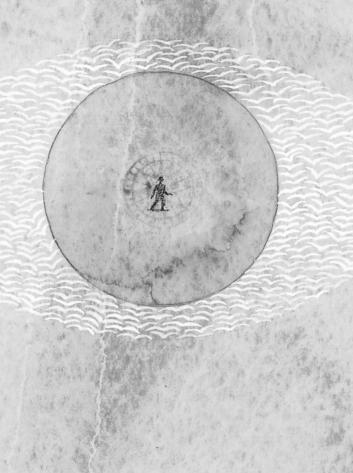

When the poet Attar woke up one morning after an uneasy dream, he realized that he was a hoopoe bird...

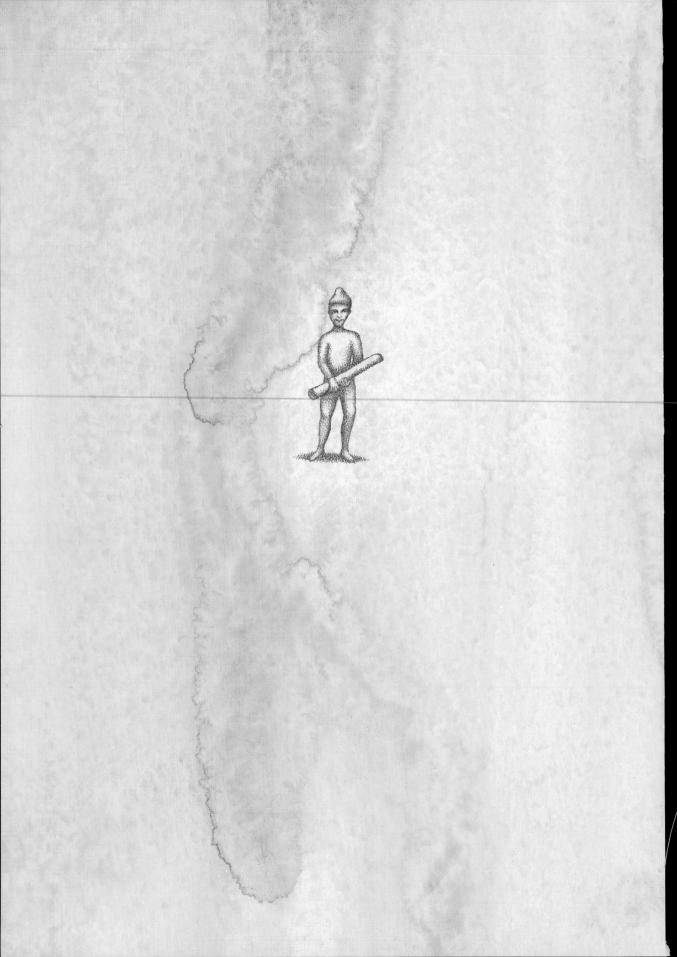

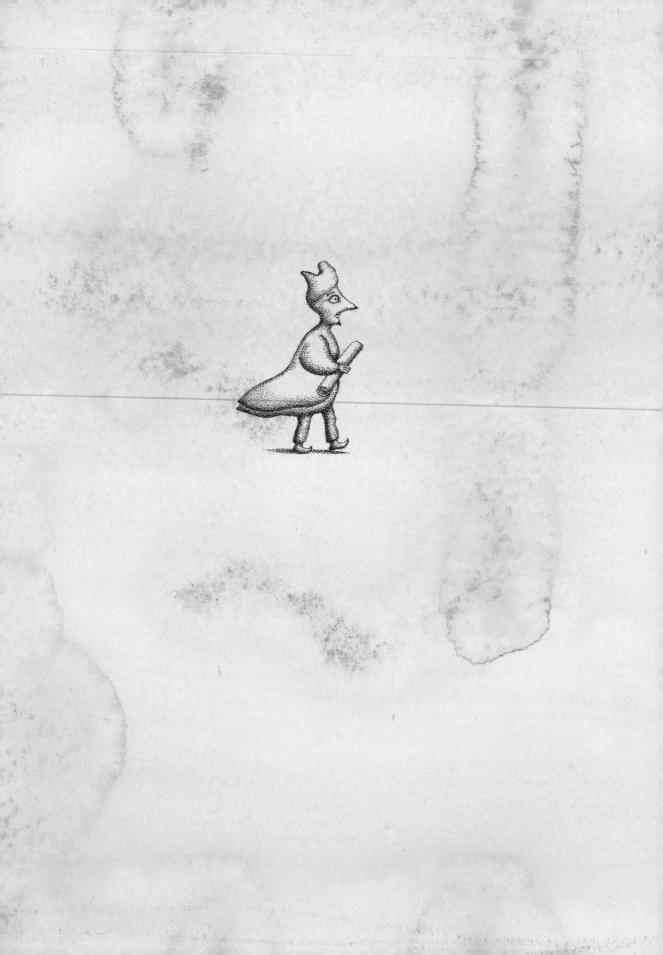

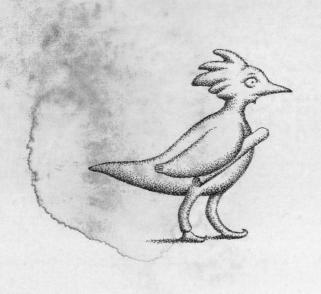

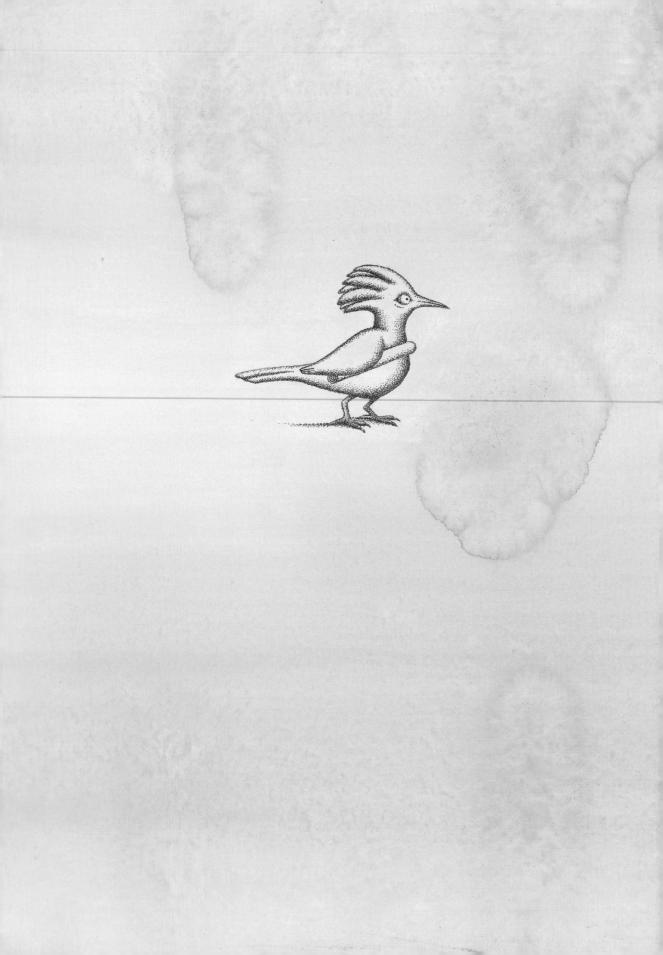

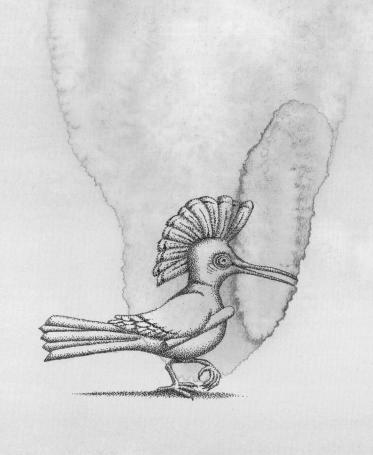

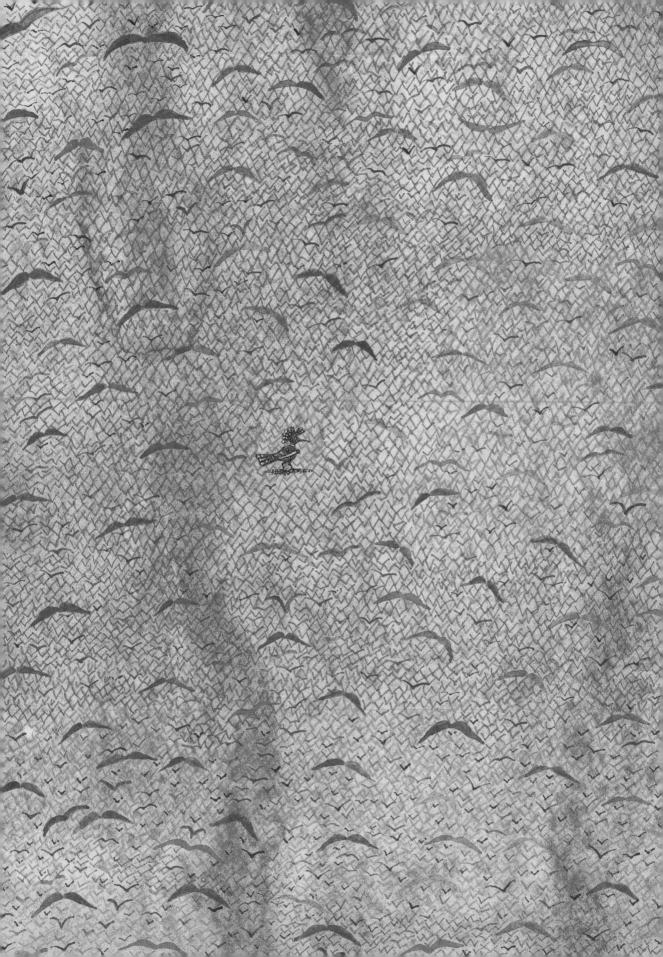

Part I

In which all the birds
of the world get together
for a conference and
are addressed by the
hoopoe bird.

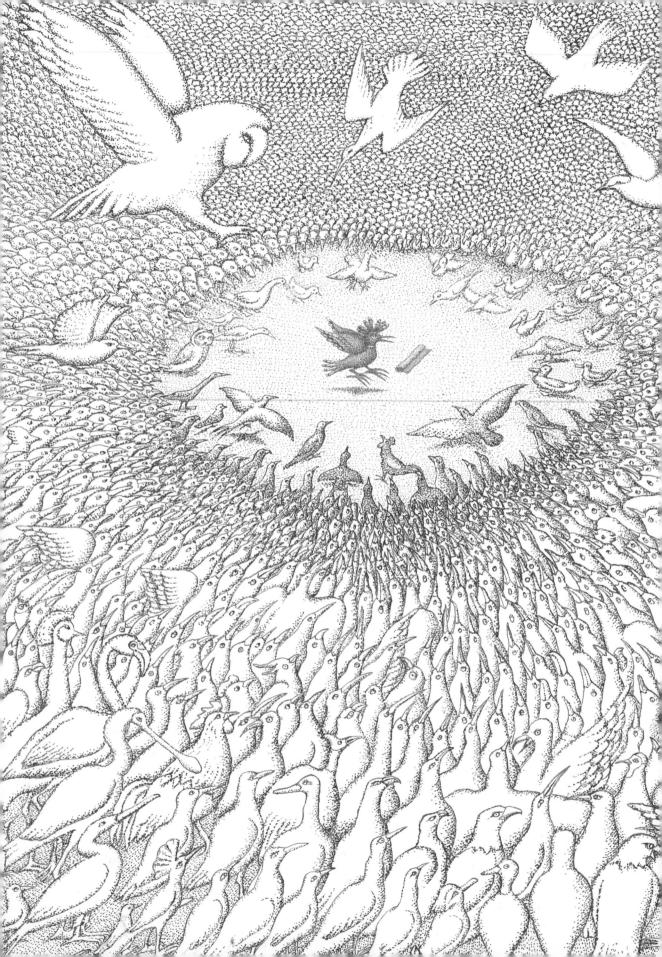

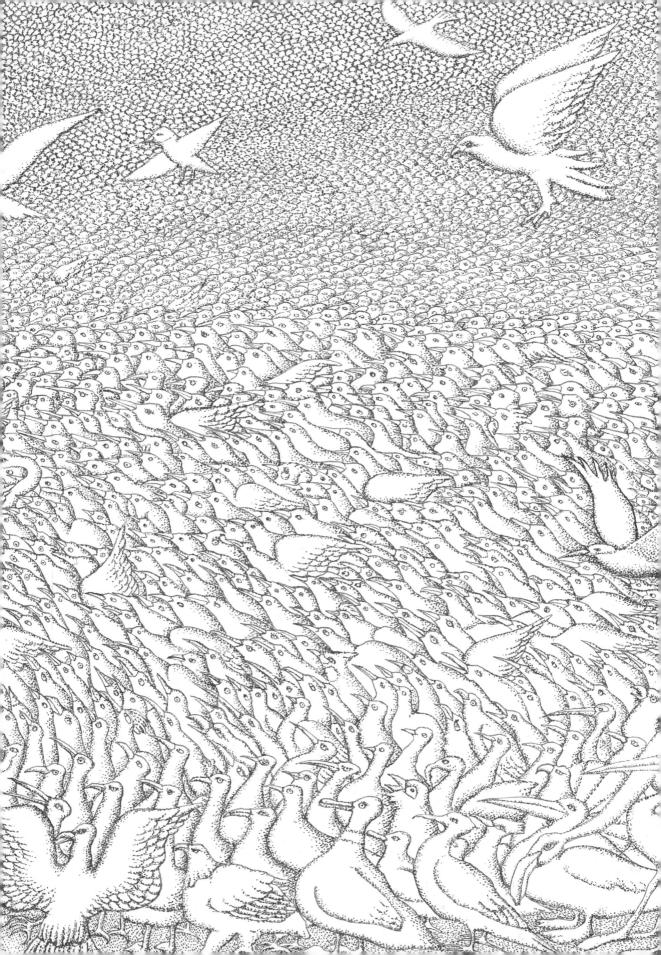

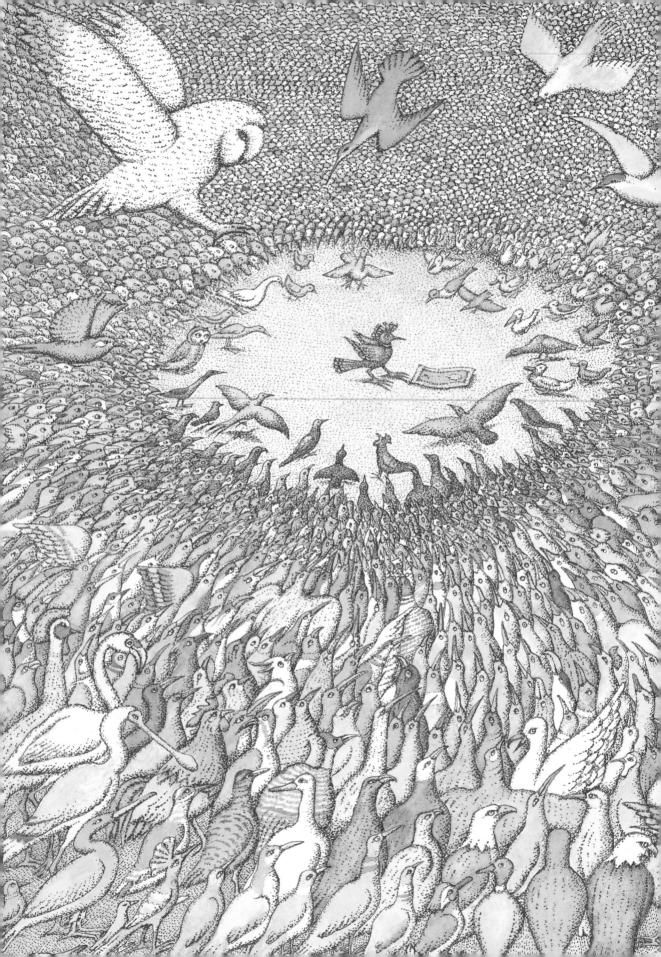

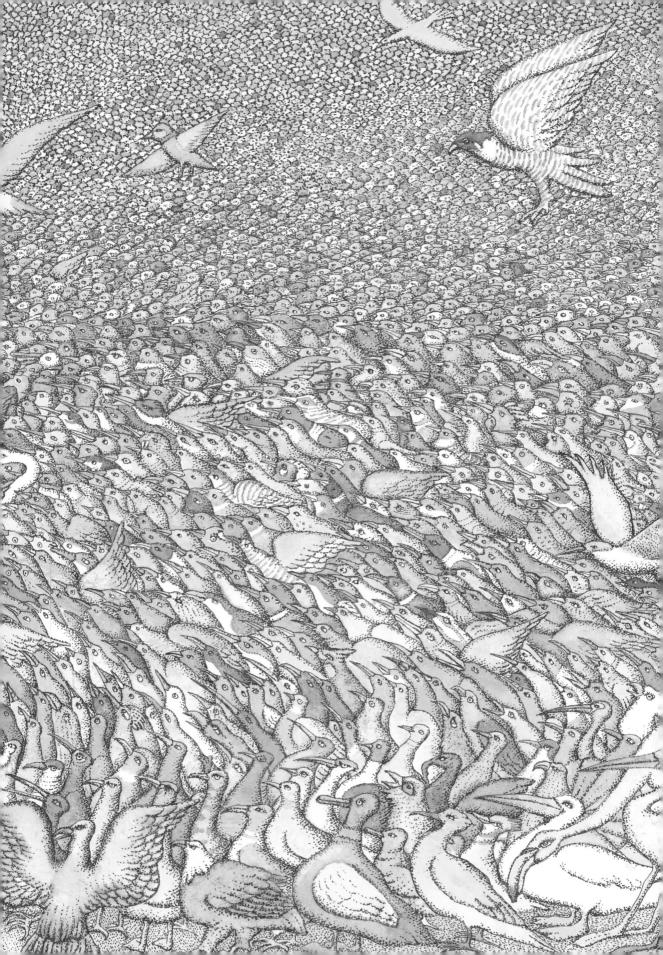

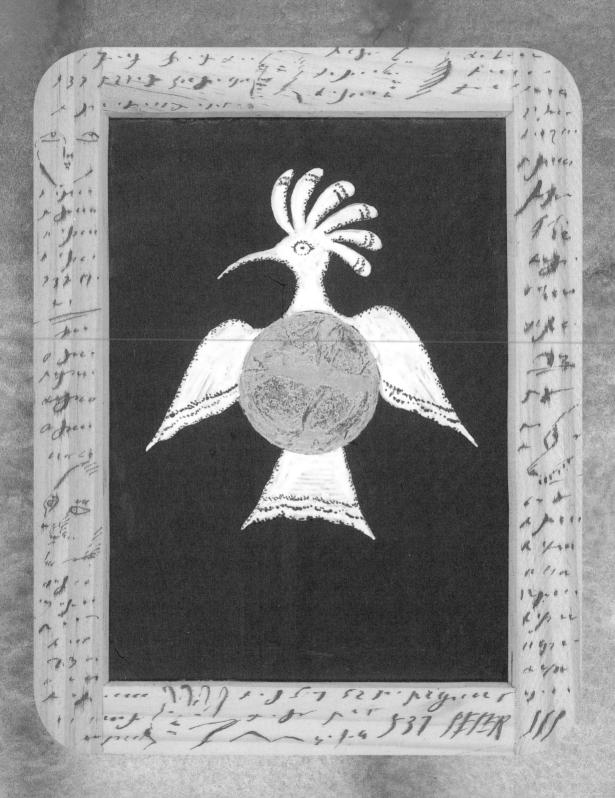

Birds!

Look at the troubles happening in our world!

Anarchy-discontent-upheaval!

Desperate fights over territory, water, and food!

Poisoned air! Unhappiness!

I fear we are lost. We must do something!

I've seen the world. I know many secrets.

Listen to me: I know of a king who has all the answers.

We must go and find him.

KINGS-WE(HAD ENOUGH OF KINGS! WHAT IS THE USE OF ANOTHER

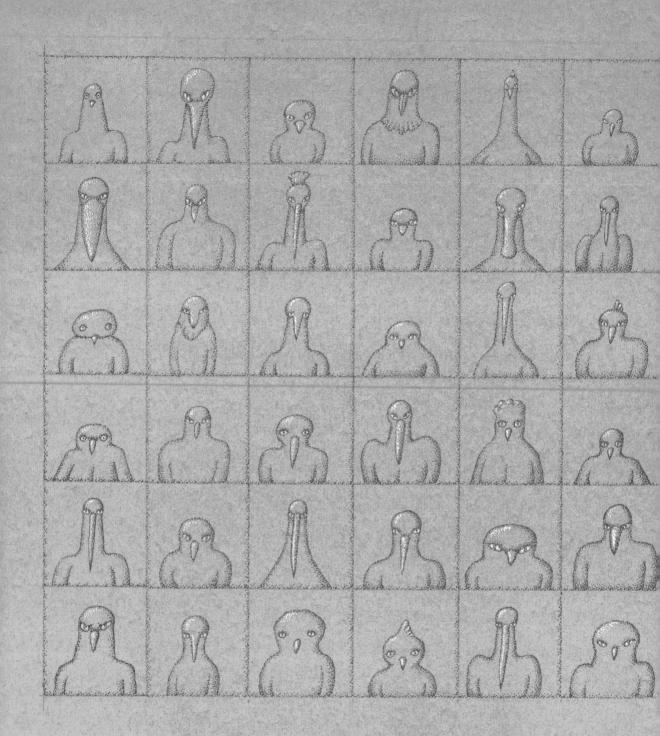

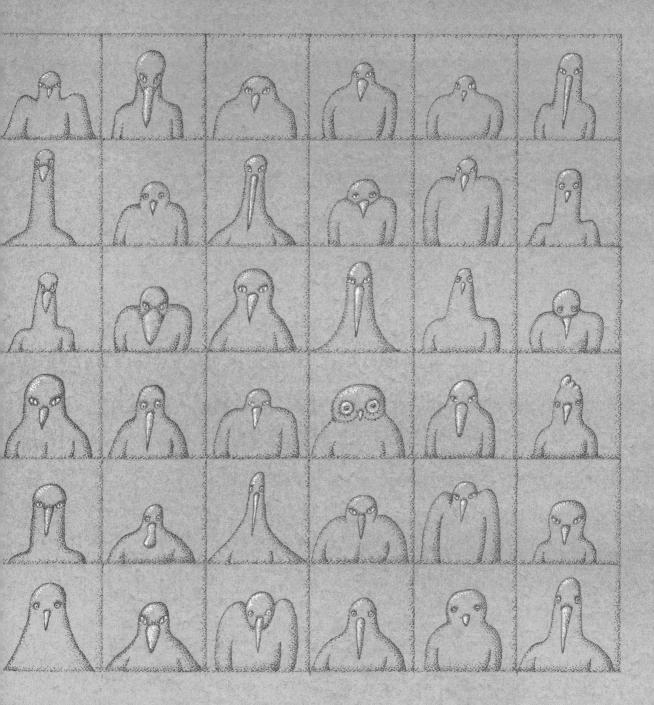

How do we know this king exists?

There's proof he exists. Look!

Here's a drawing of one of his feathers.

It fell to the ground in China

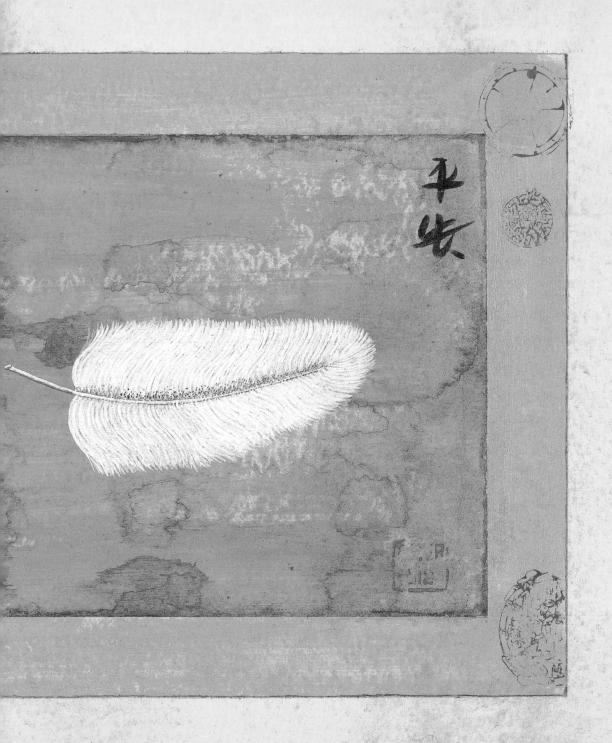

in the middle of the night.

Word got out immediately.

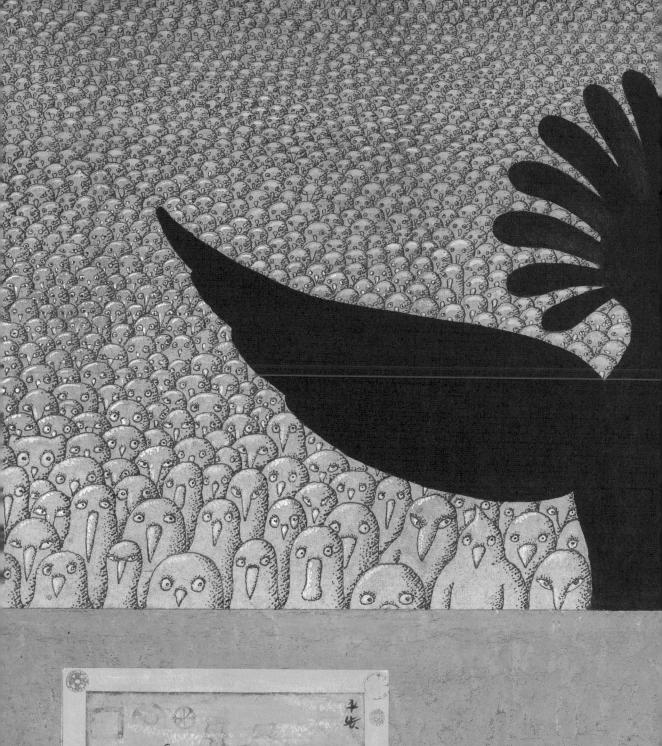

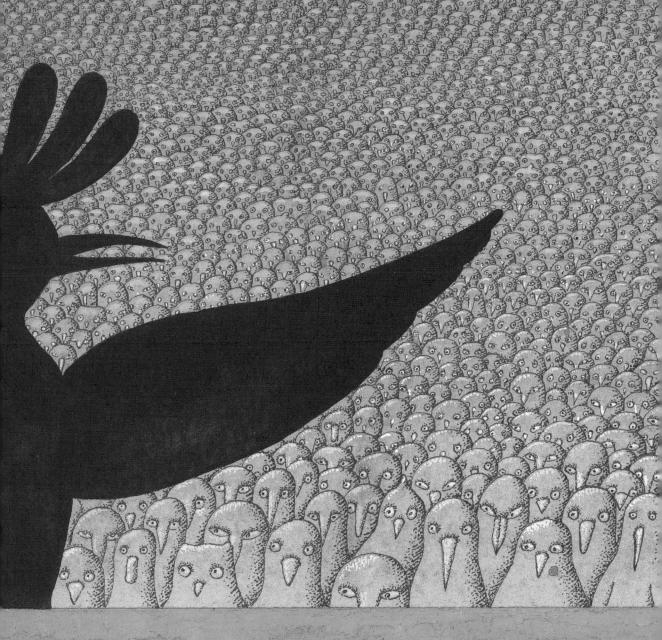

This king is real!

He is as close to us as we are far from him.

His name is Simorgh

and he lives on the mountain of Kaf.

Let us go and find him.

HOOPOE: Simorgh is hidden behind the veil of clouds.

BIRDS: What veil? WI BIRDS: What veil? What clouds? HOOPOE: Your heart is behind the veil.

Part II

In which the birds realize that this will be a difficult journey and are reluctant to give up their comforts.

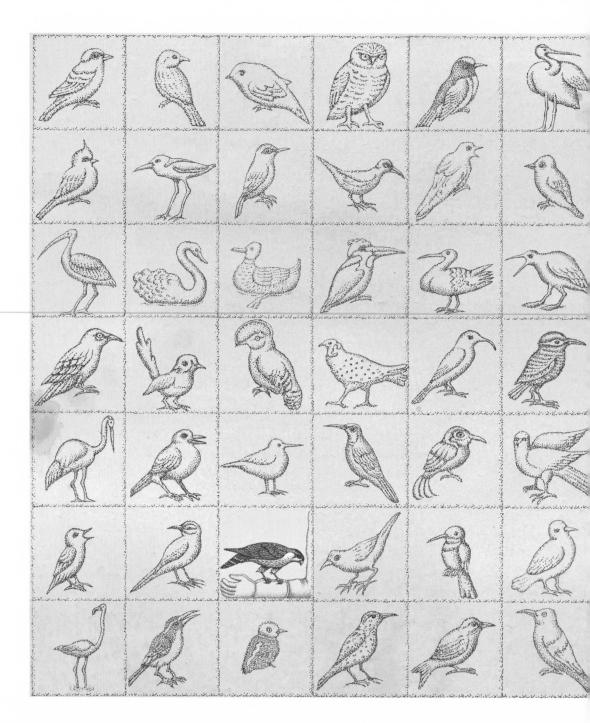

some birds have doubts

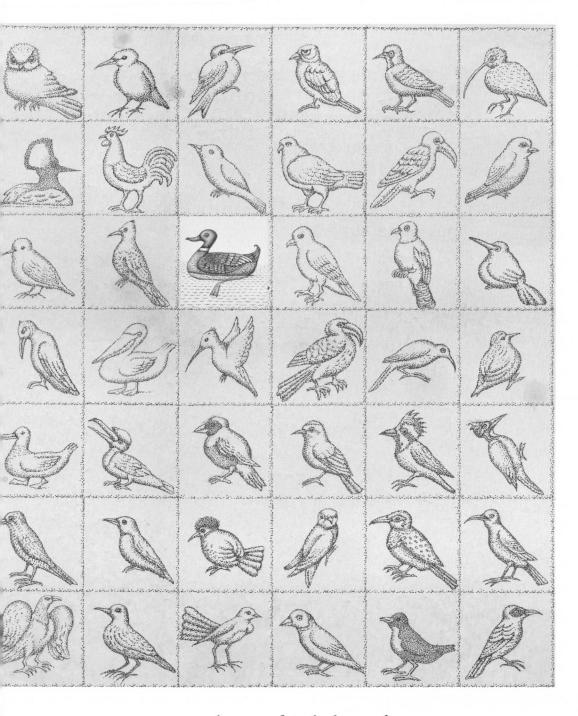

and some birds have fears

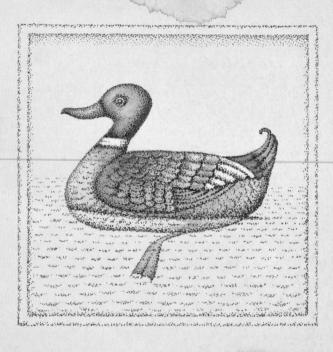

Duck: I'm happy in water!

It's the source of everything.

There's plenty of water where we're going.

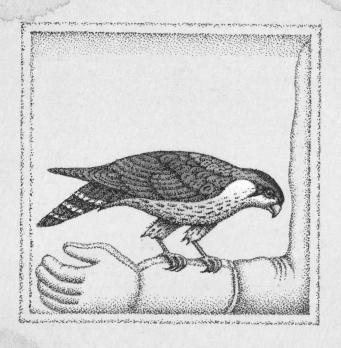

Falcon: I already have a master!

You like following orders? Follow me!

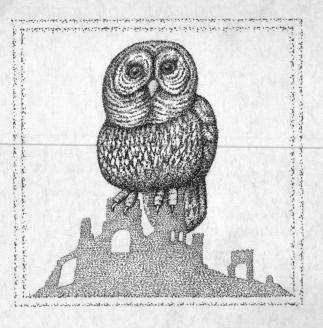

Owl: I love searching for shiny treasure among the ruins!

Come with us and search new places.

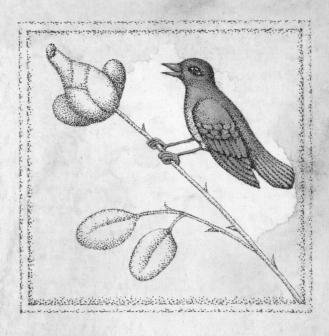

Nightingale: I live for love.

My rose and I are one.

How could I leave my rose?

Better watch for thorns!

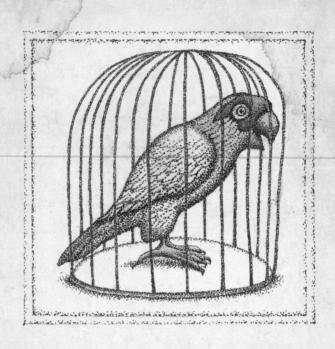

Parrot: I like it here.

I feel safe.

They bring me food and water every day.

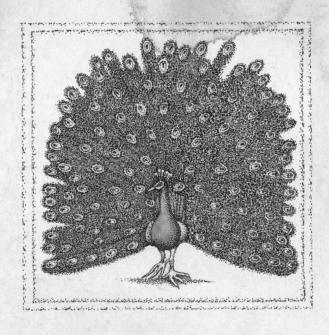

Peacock: I'm special!
I'm not like anybody else—
look at all my colors!

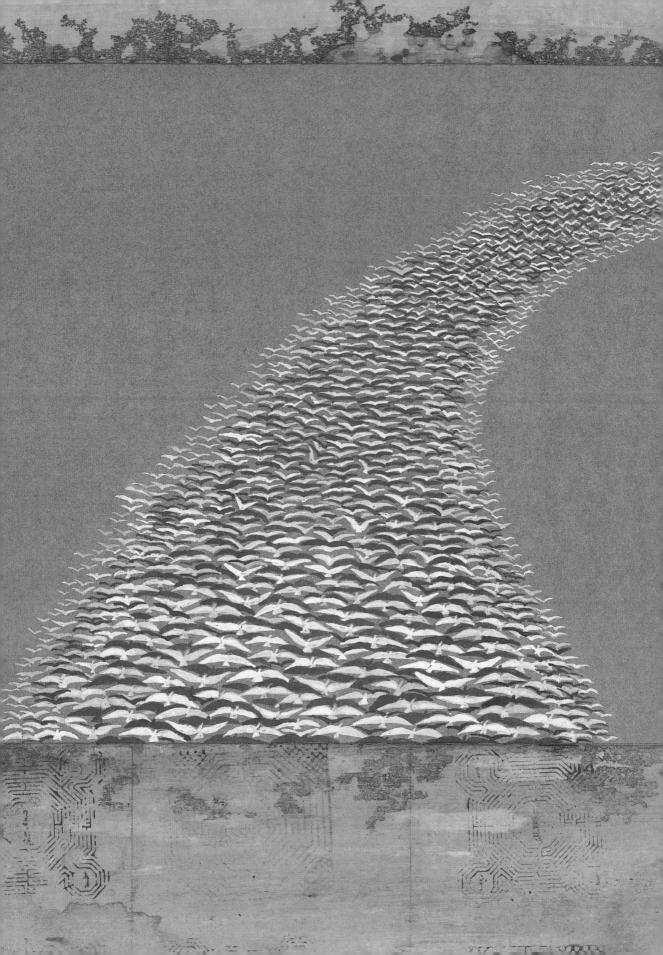

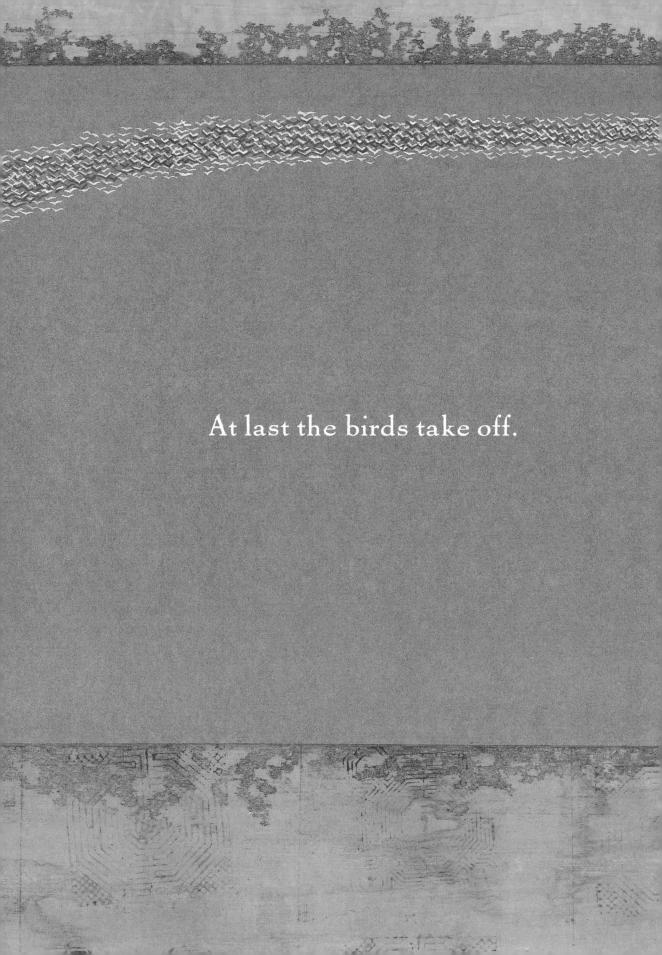

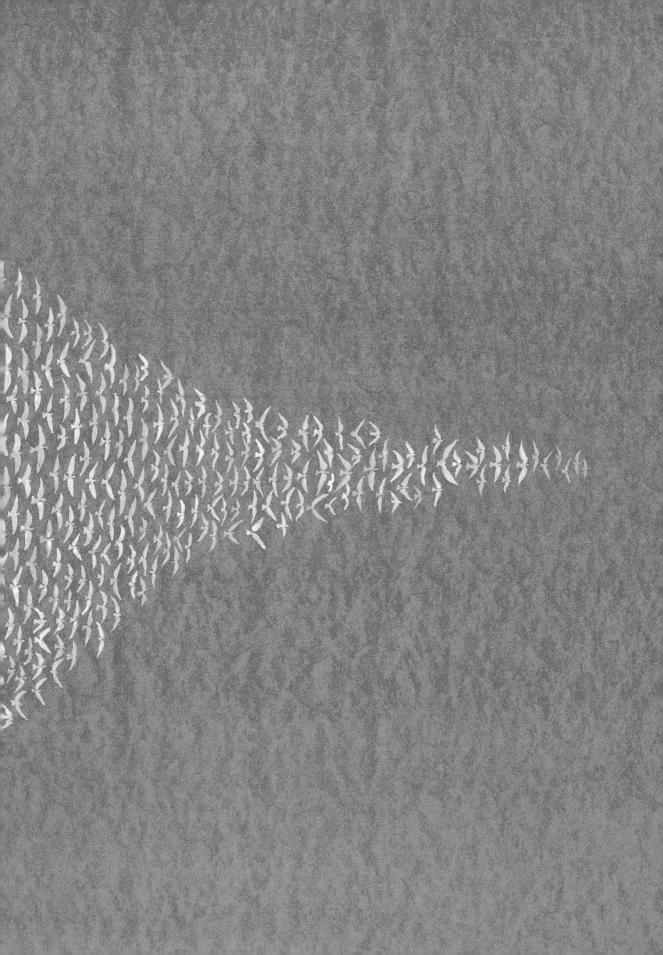

Part III

In which the birds fill all the corners of the world.

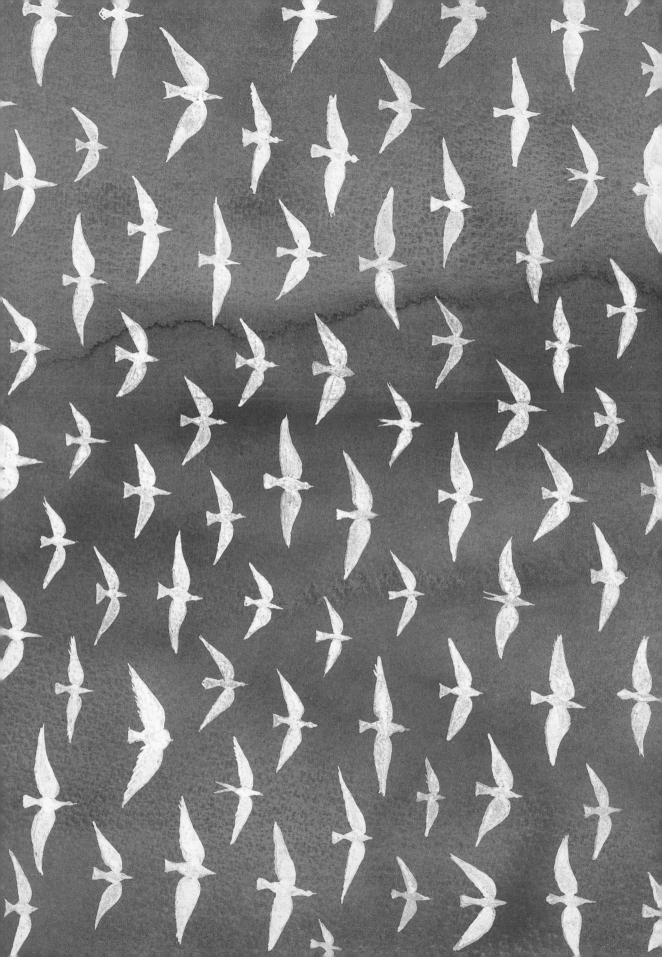

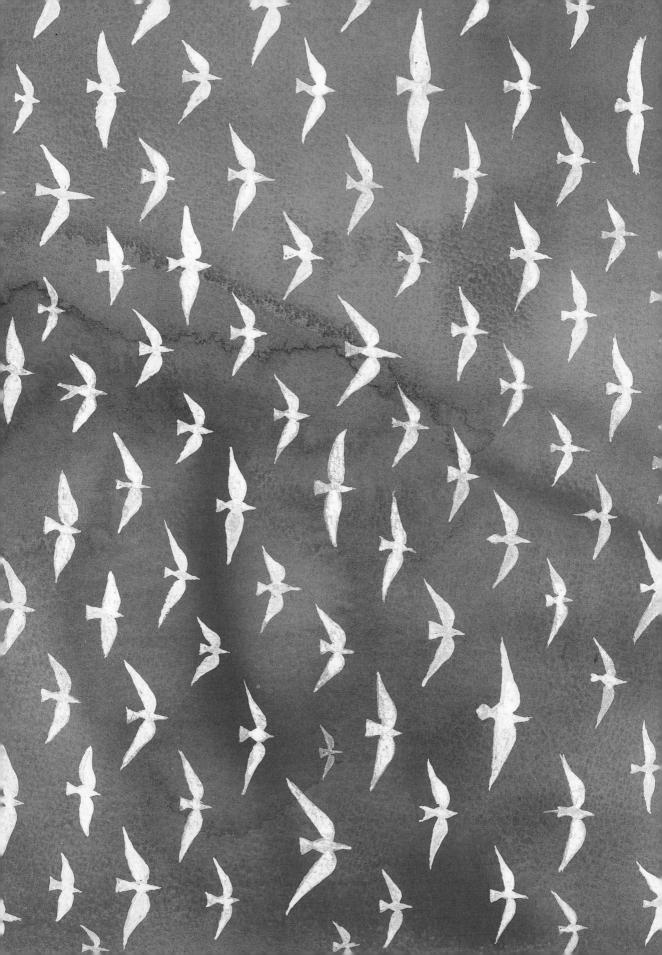

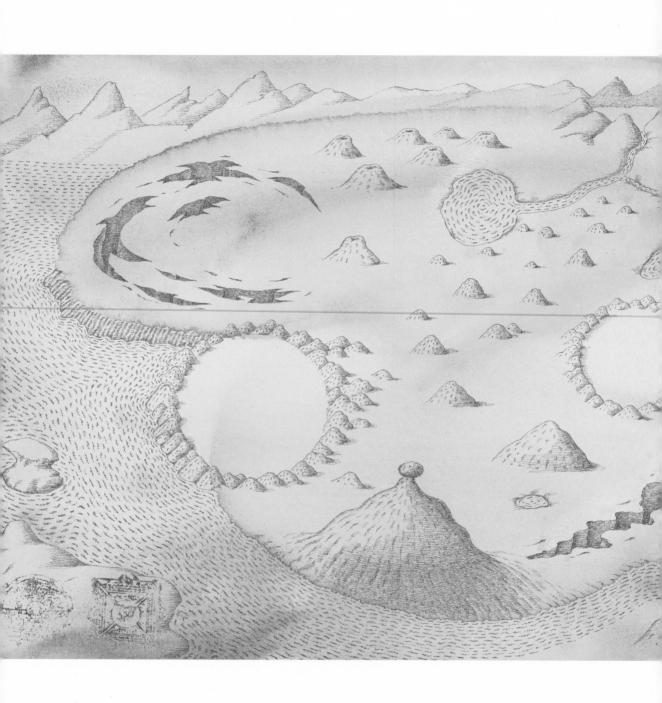

Come on, you brave birds! Let's glide, let's fly, let's soar.

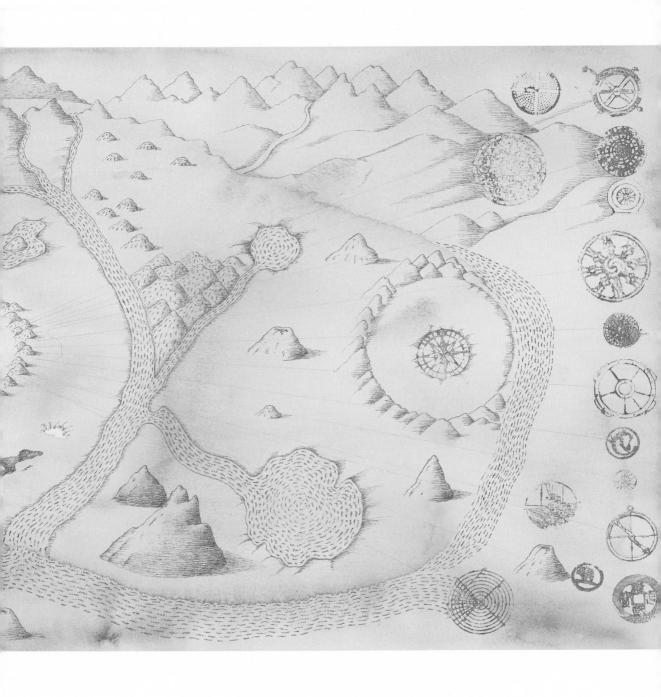

Love loves difficult things.
We're on our way!

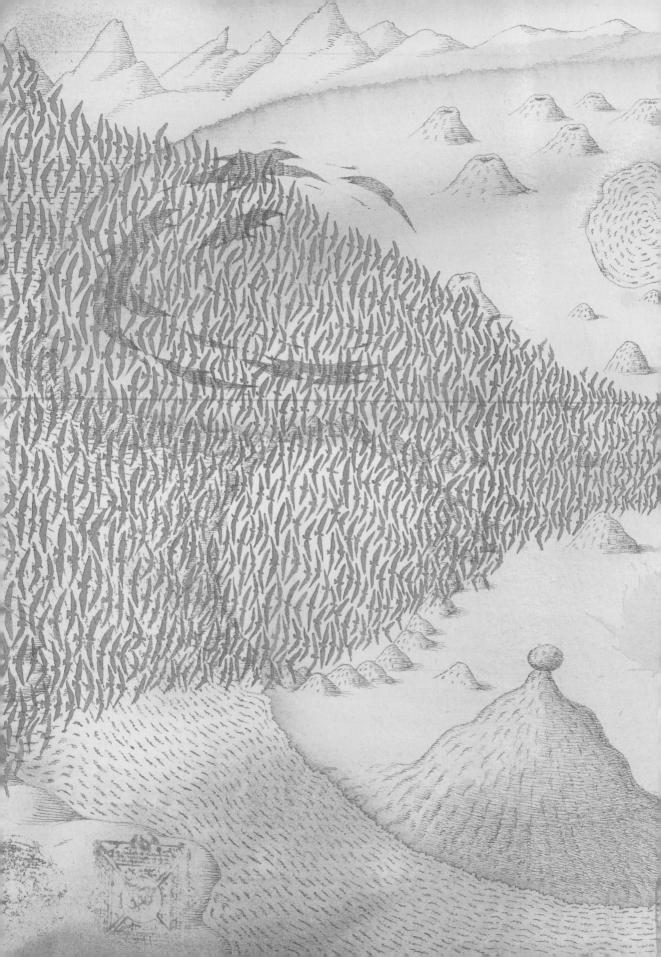

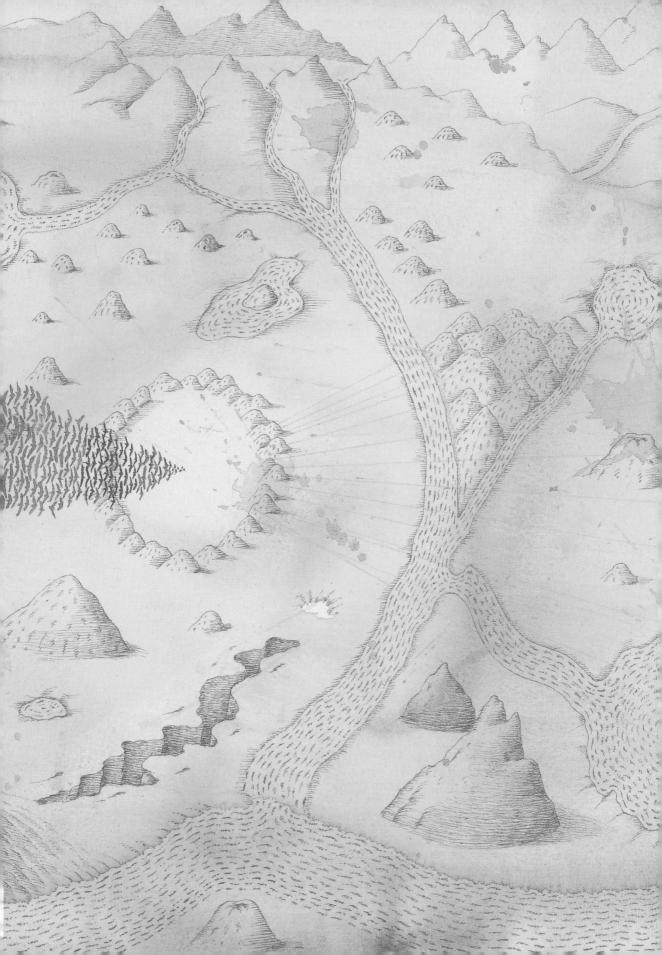

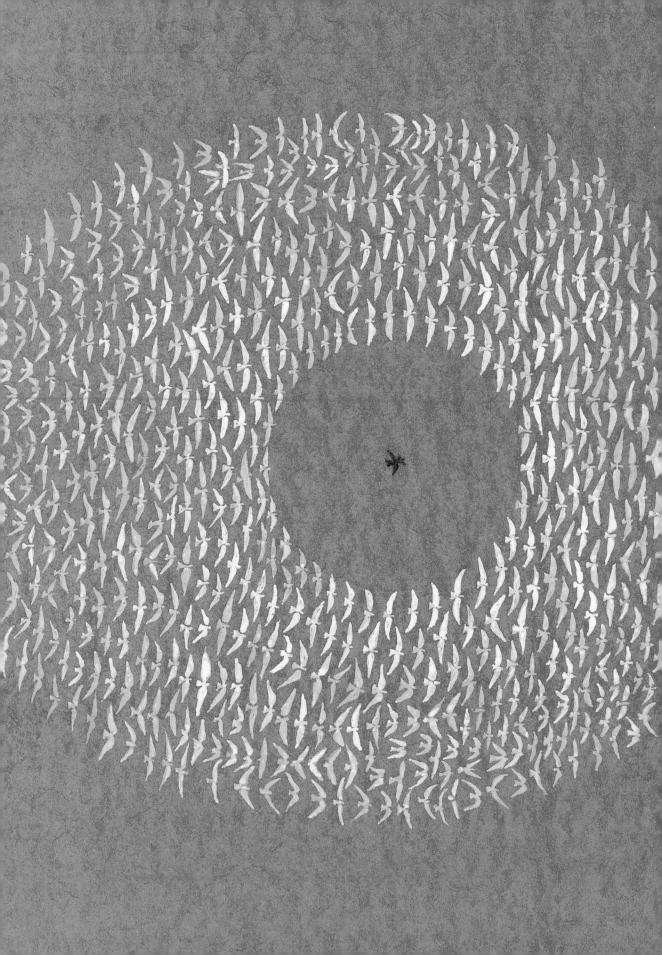

The endless deserts are crystals of sand. The mountain ranges are a string of beads.

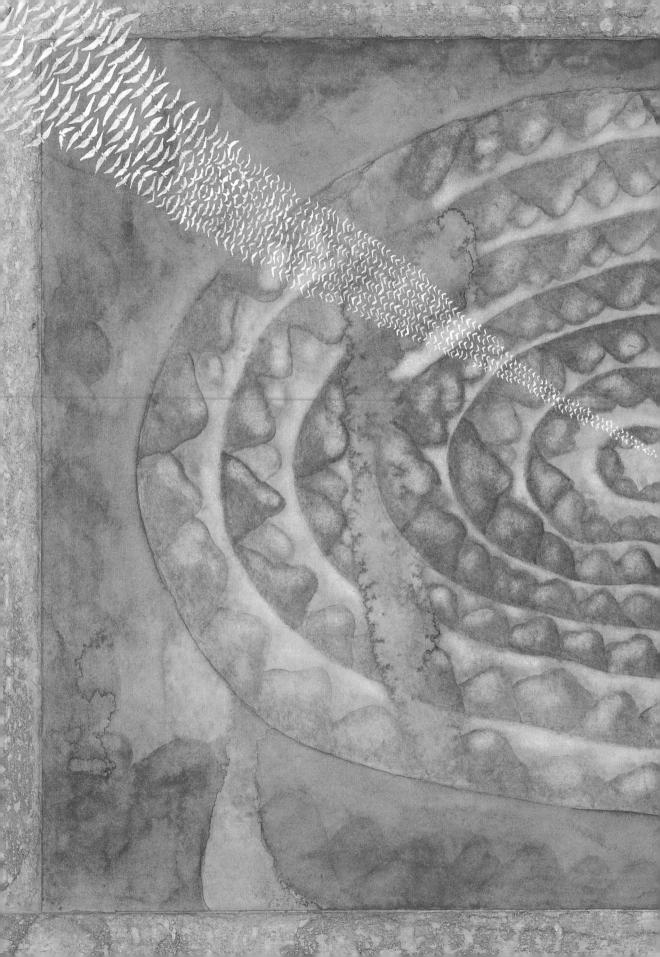

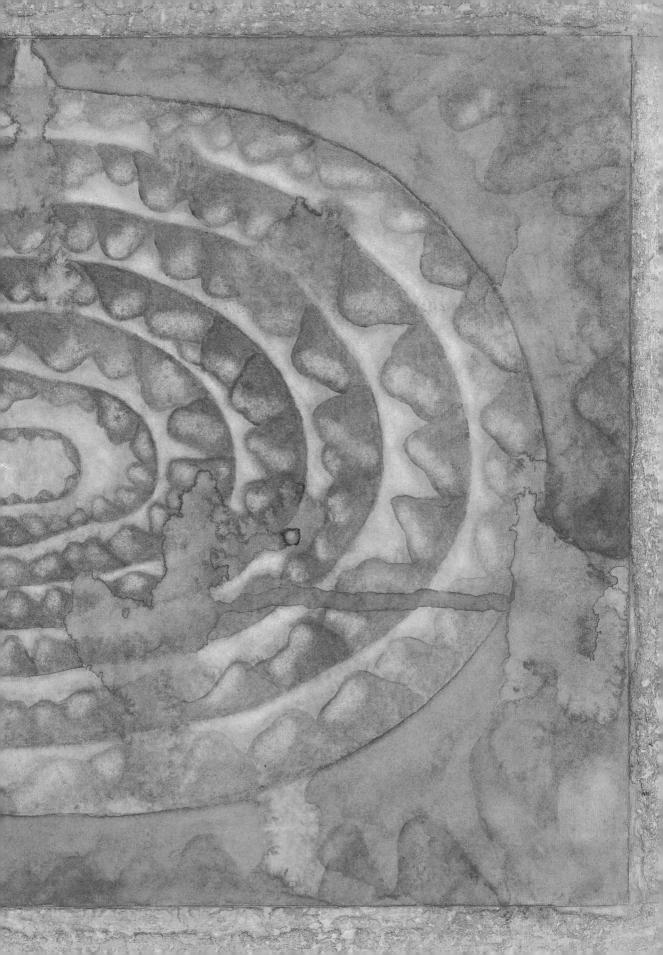

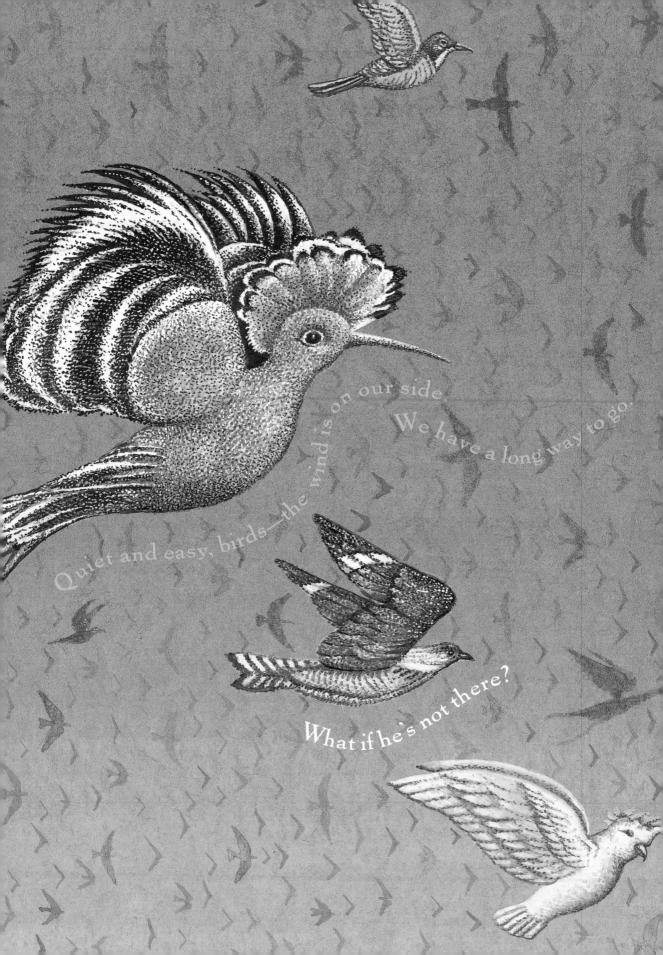

low much last a do we have to go? I wonder what this Simorsh looks like. Is he going to feed us?—that's what I want to know.

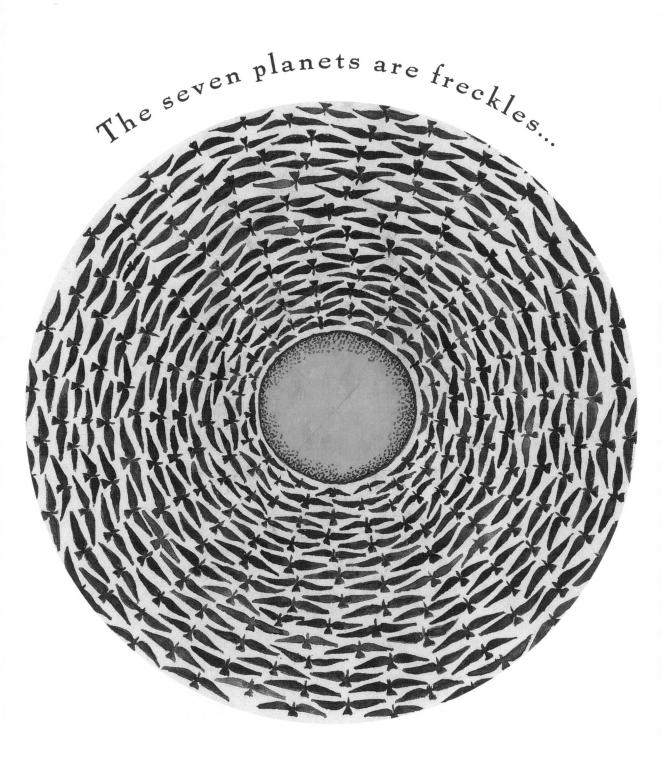

The seven oceans are drops of rain...

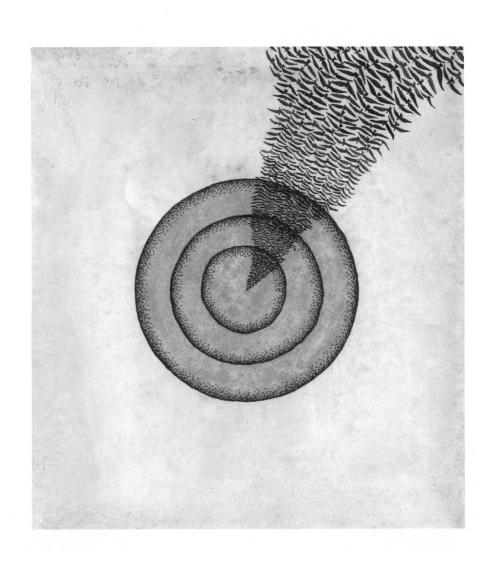

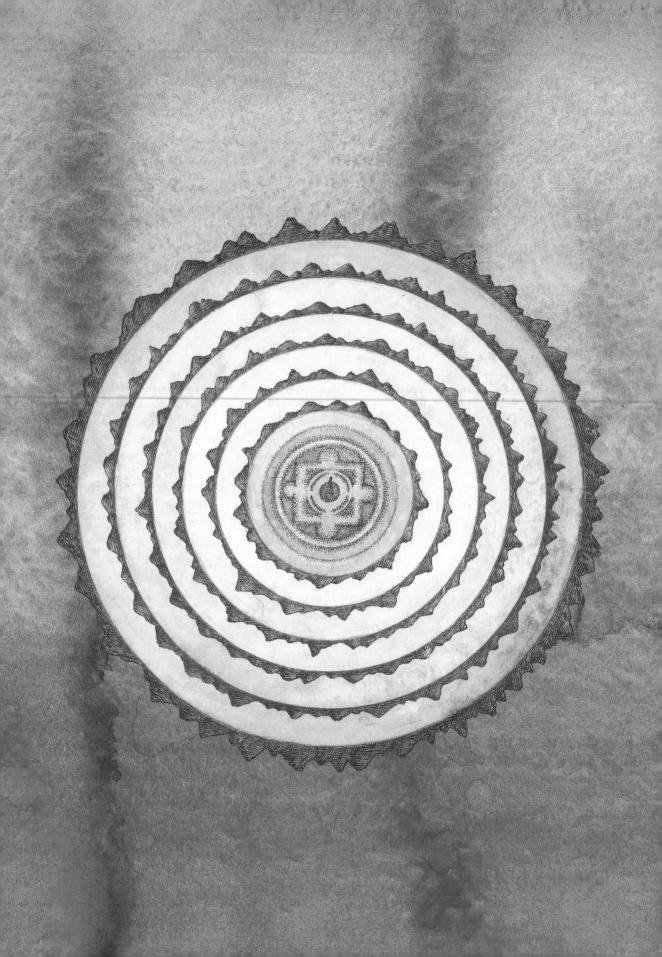

Part IV

In which the birds have to cross seven valleys.

The Valley of Quest

The Valley of Love

The Valley of Understanding

The Valley of Detachment

The Valley of Unity

The Valley of Amazement

The Valley of Death

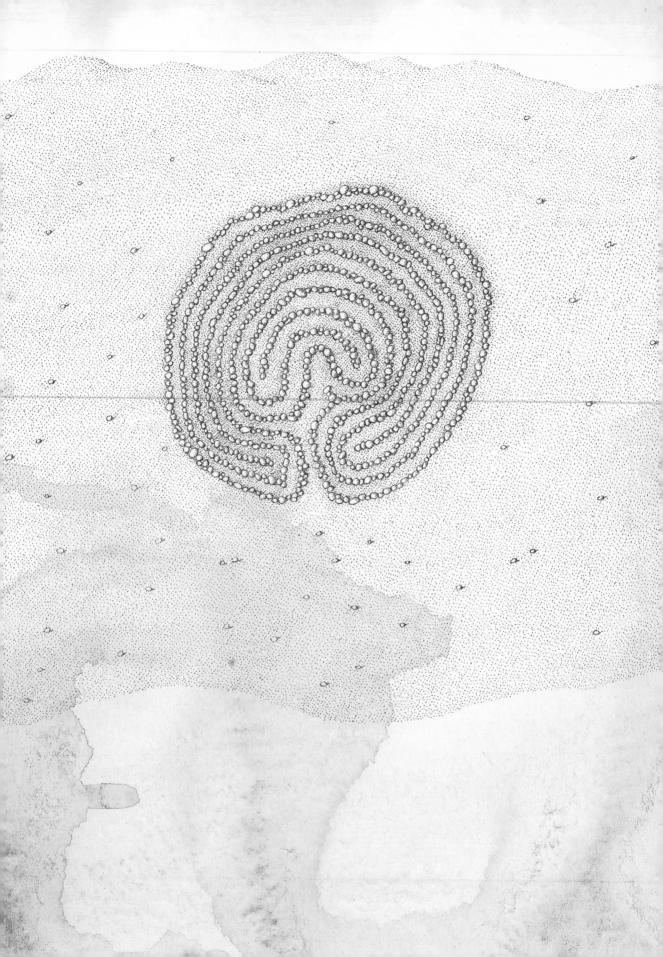

The Valley of Quest

- P peaceful
- A auspicious
- T truthful
- I intense
- E enduring
- N numbing
- C calming
- E eternal

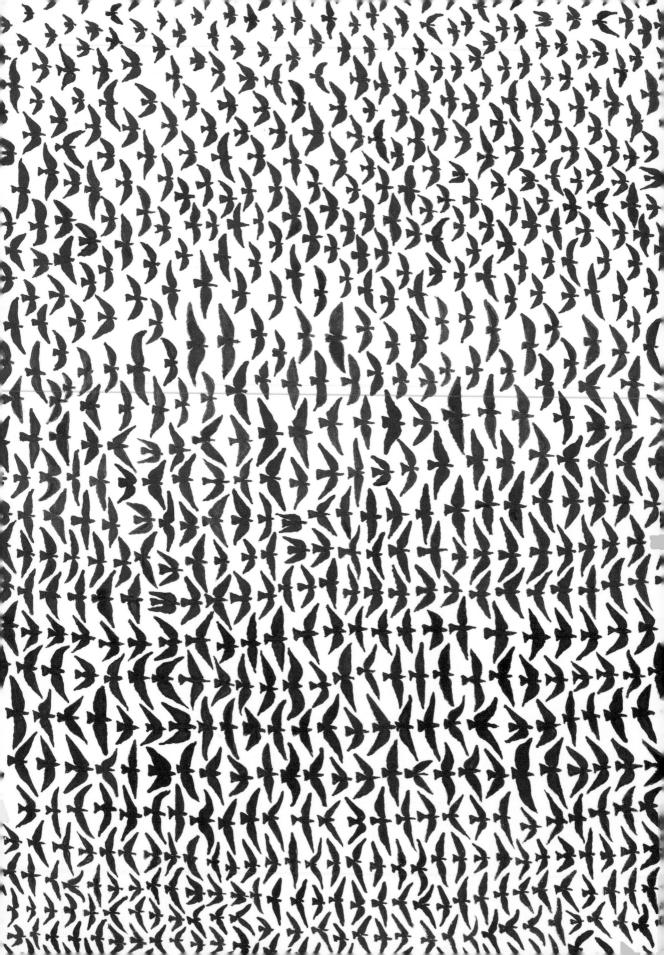

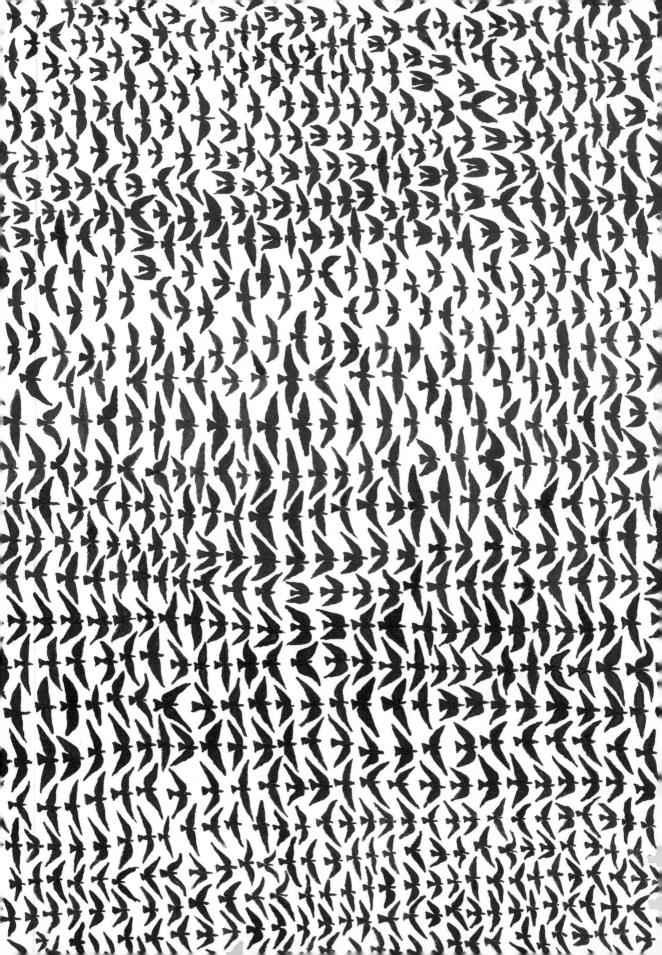

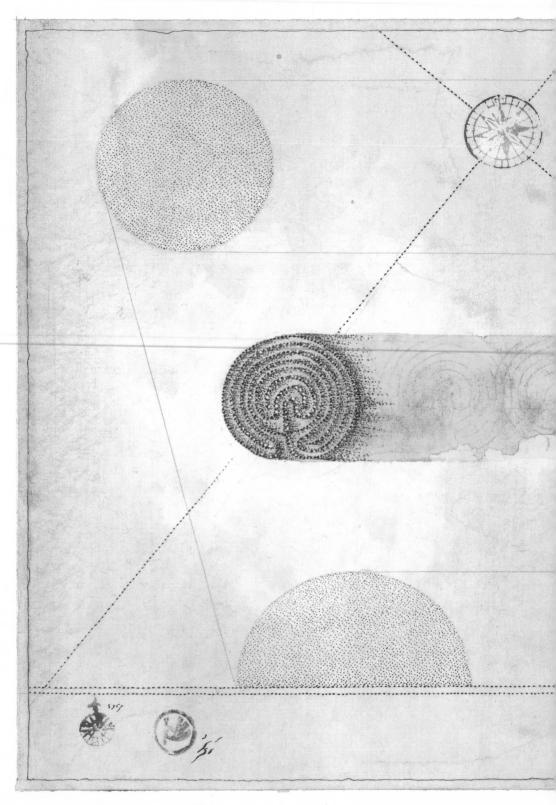

Jettison your obsessions, your power,

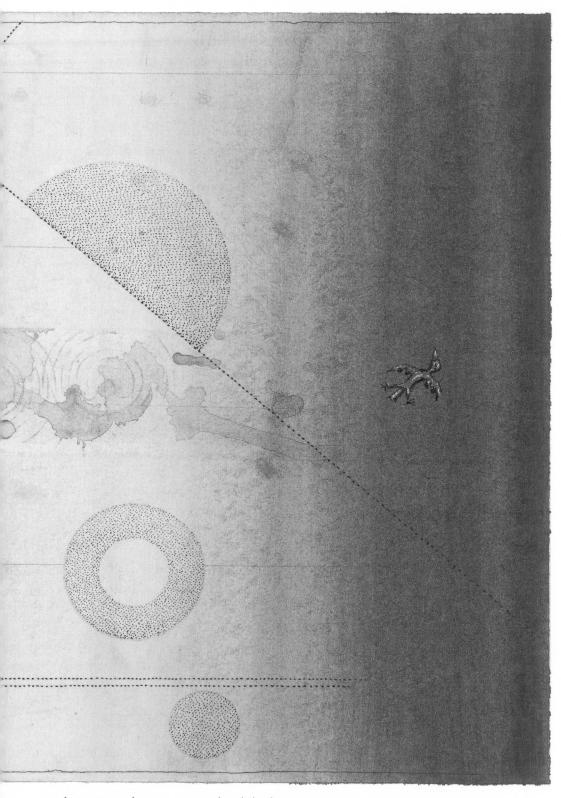

and everything you hold dear.

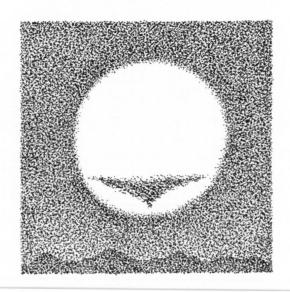

The birds settle for the night.

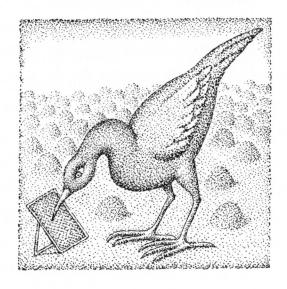

The obsessive bird, sifting the earth through a sieve, says, I'm trying to find my way, so I must look everywhere.

Hoopoe: When you feel empty, you have to open up your heart and let the wind sweep through it.

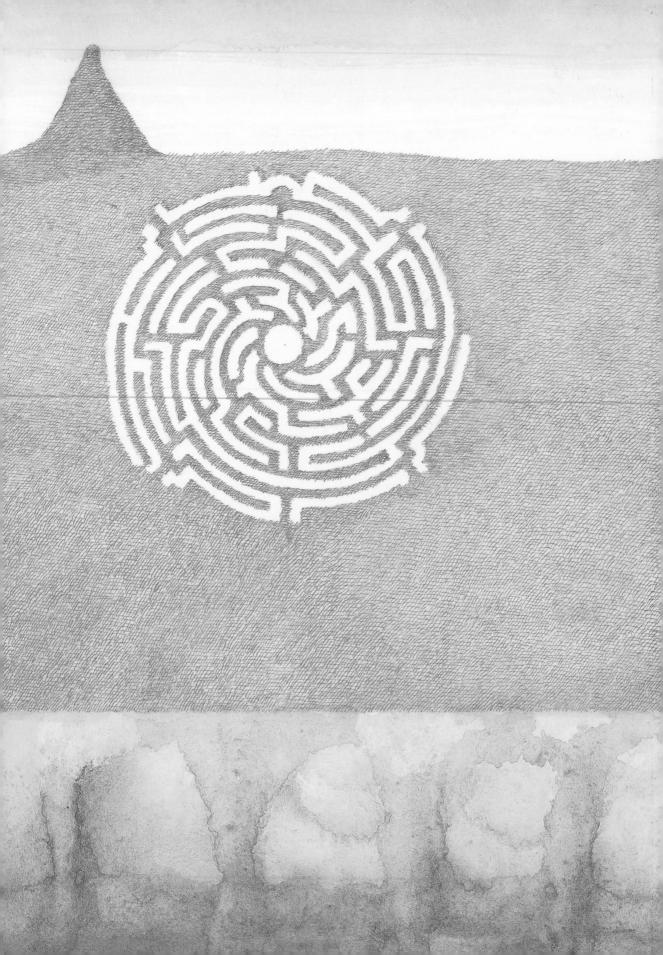

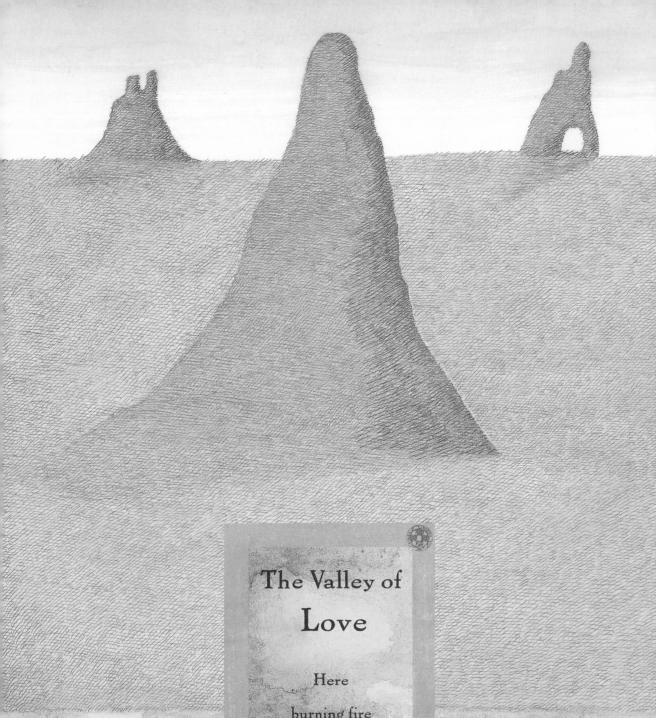

Here
burning fire
is love and
burning love
is fire.

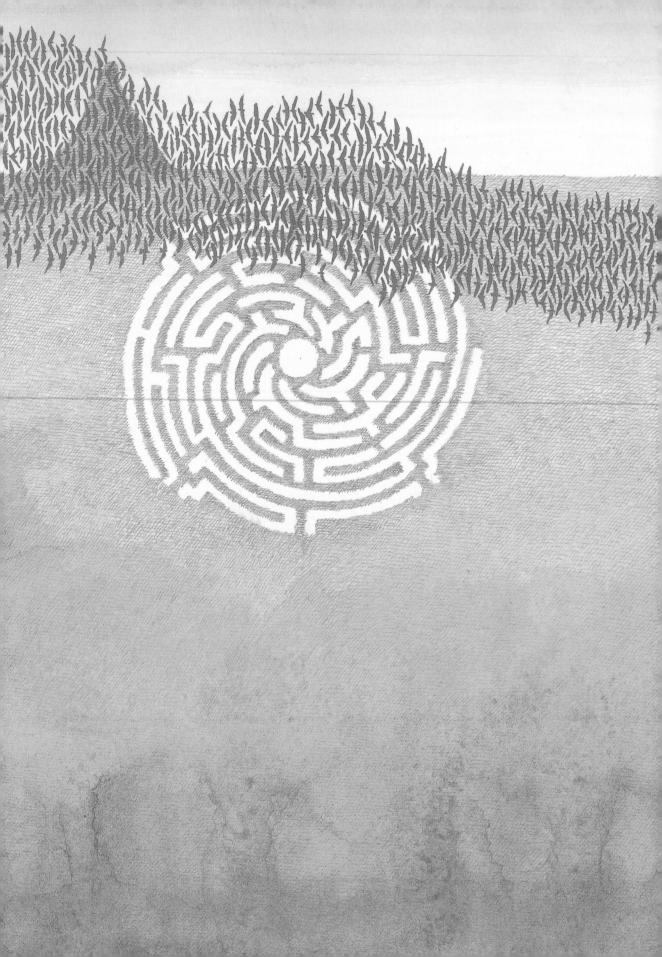

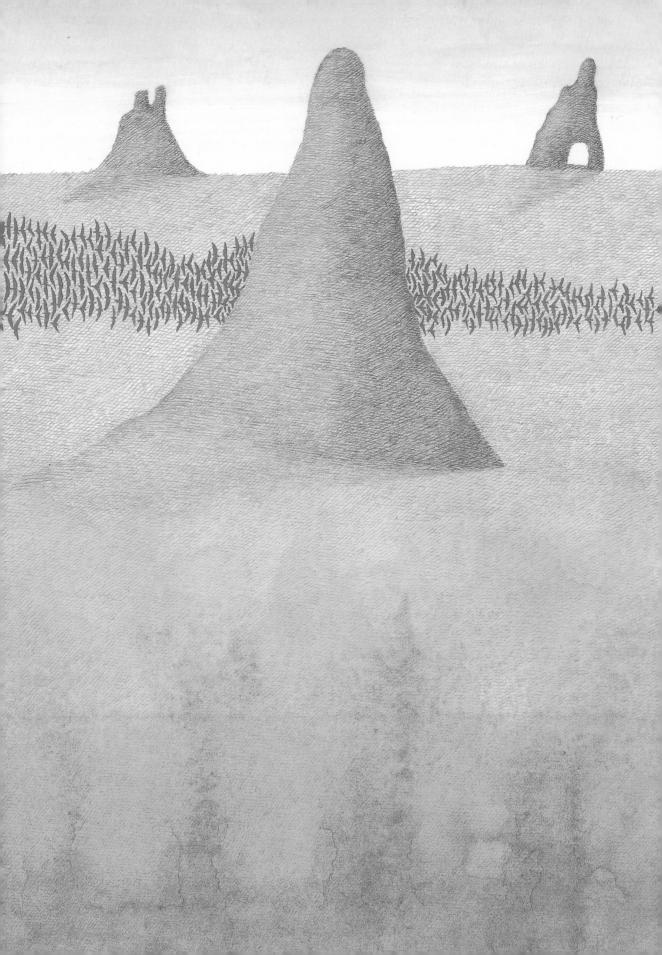

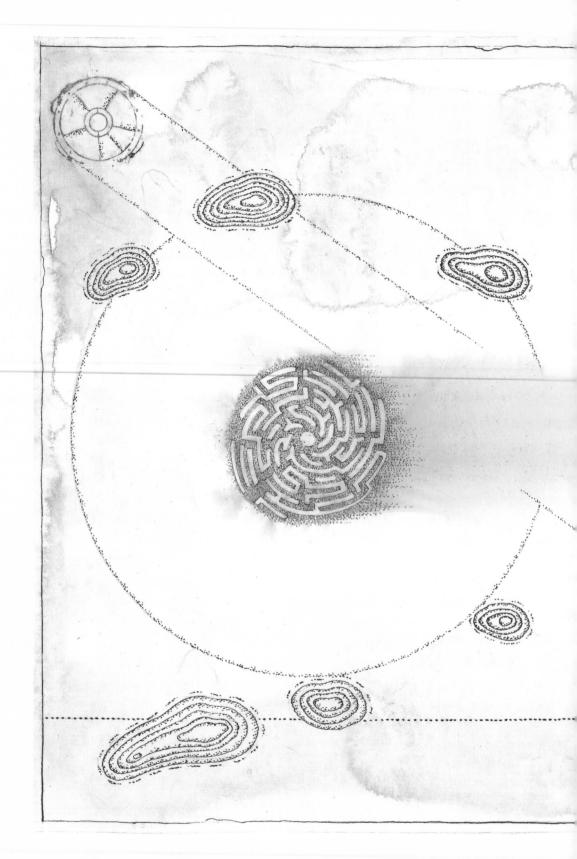

The pyre of love is...simmering and constant...

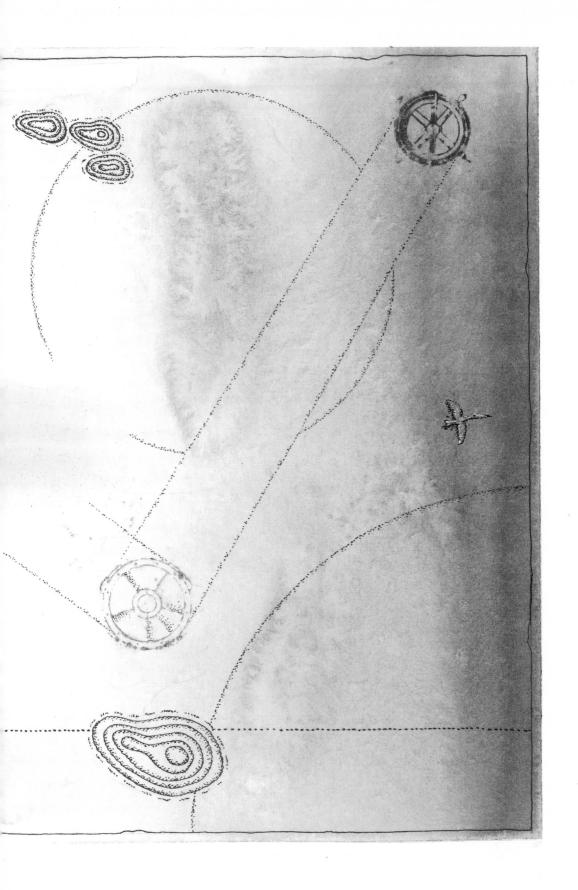

Some birds creep away under cover of darkness.

Blushing bird: I'm scared of love.

Hoopoe: Love can lift you to the top of the world or pull you to the bottom of hell.

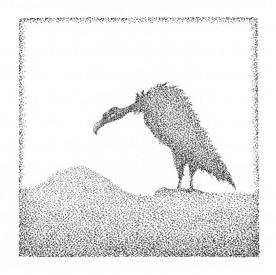

Hoopoe: The ancient gravedigger was asked if you can bury love.

He answered that he had buried many corpses over many years but had never once buried his desires.

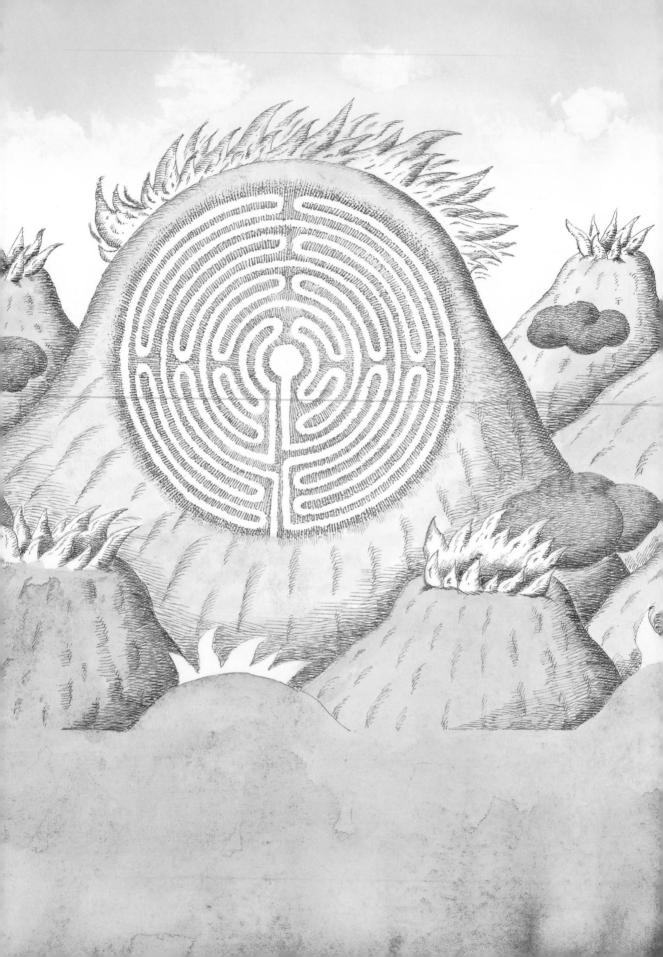

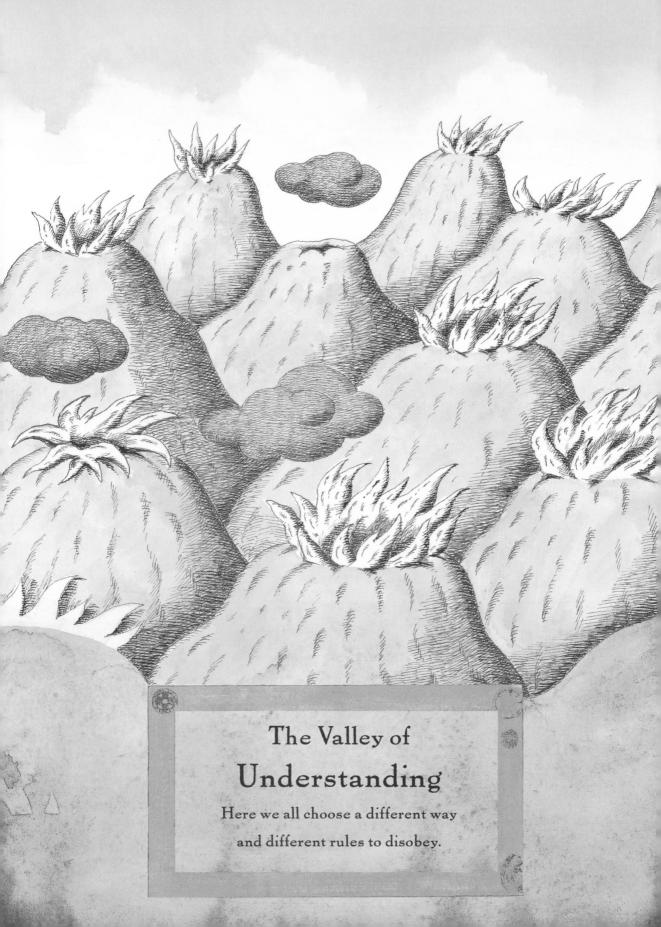

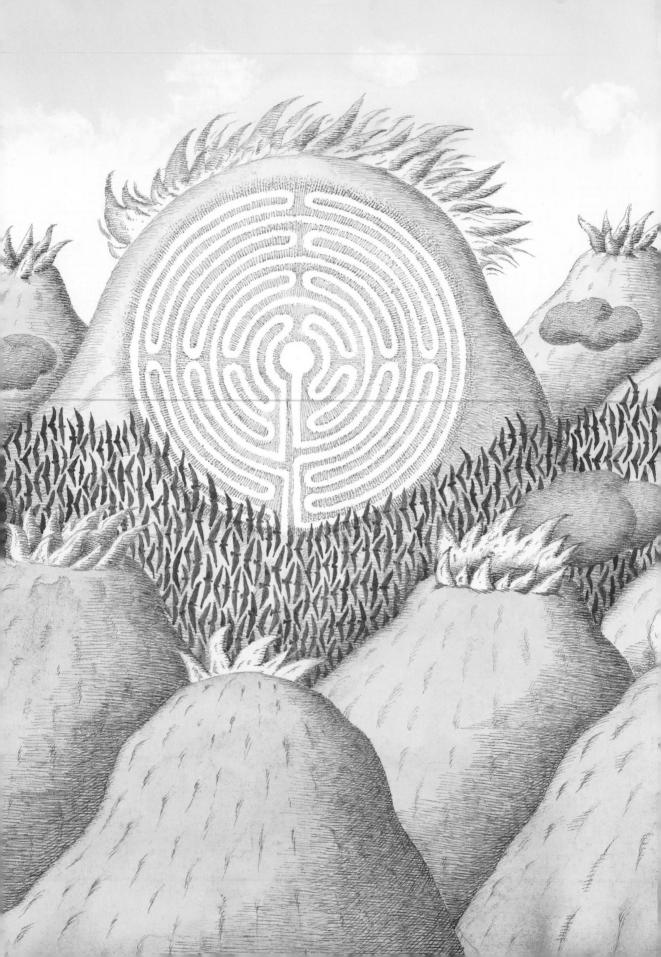

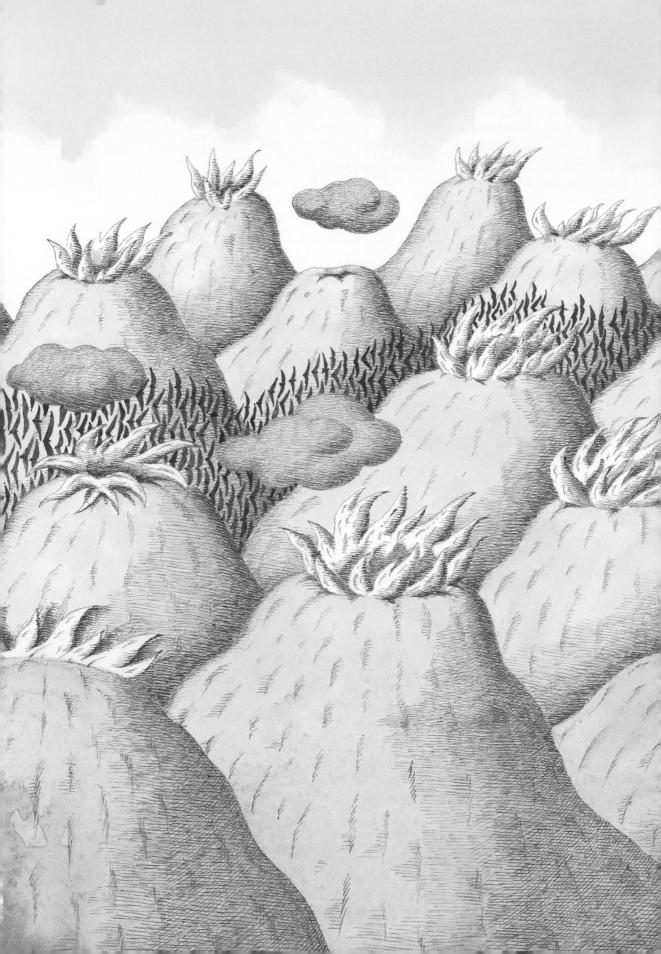

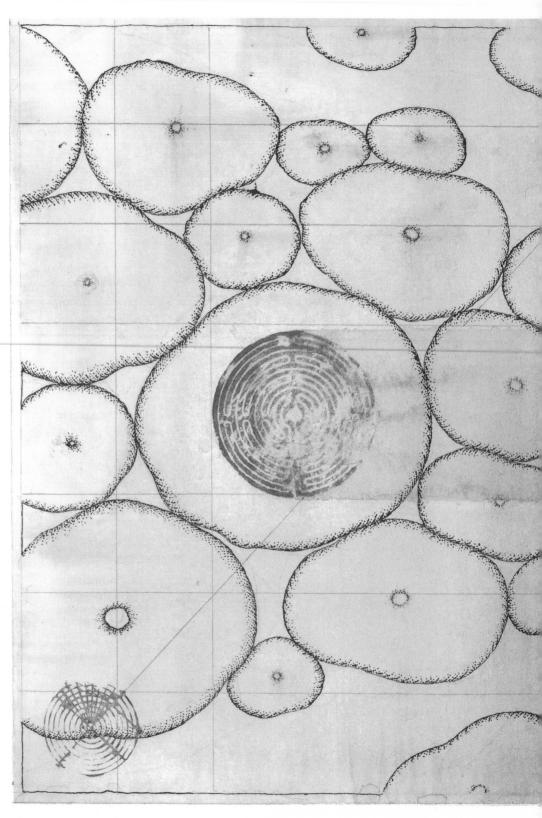

With time suspended, there is no beginning

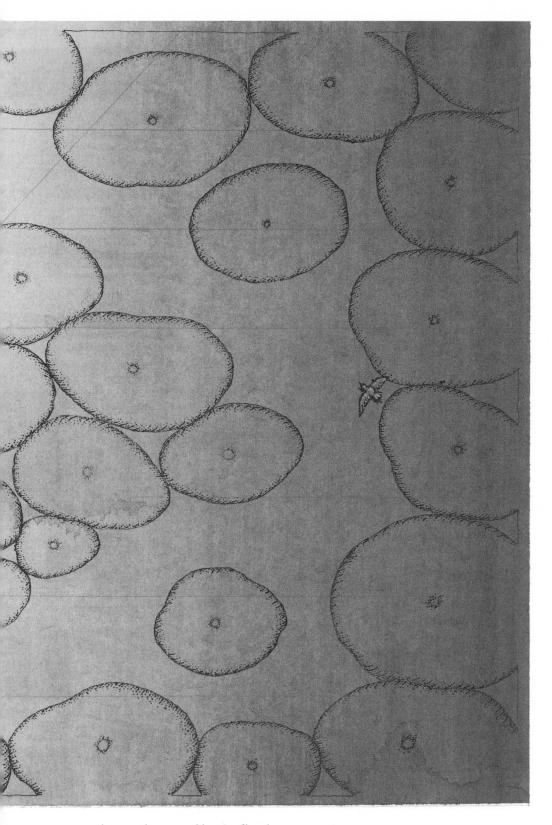

or end, only endless flight.

Birds: Where are we?
There's no understanding in this
Valley of Understanding.

Hoopoe: Here we must pay close attention. We are following a path. No one knows how long we have to go forward or how far.

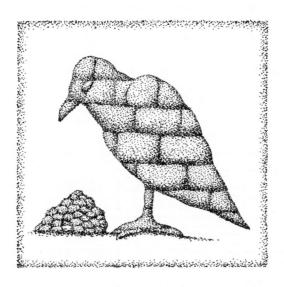

Do you know the story of the bird who lost his way? And nobody was looking for him?

He turned into stone...and cried.

He cried little pebbles...

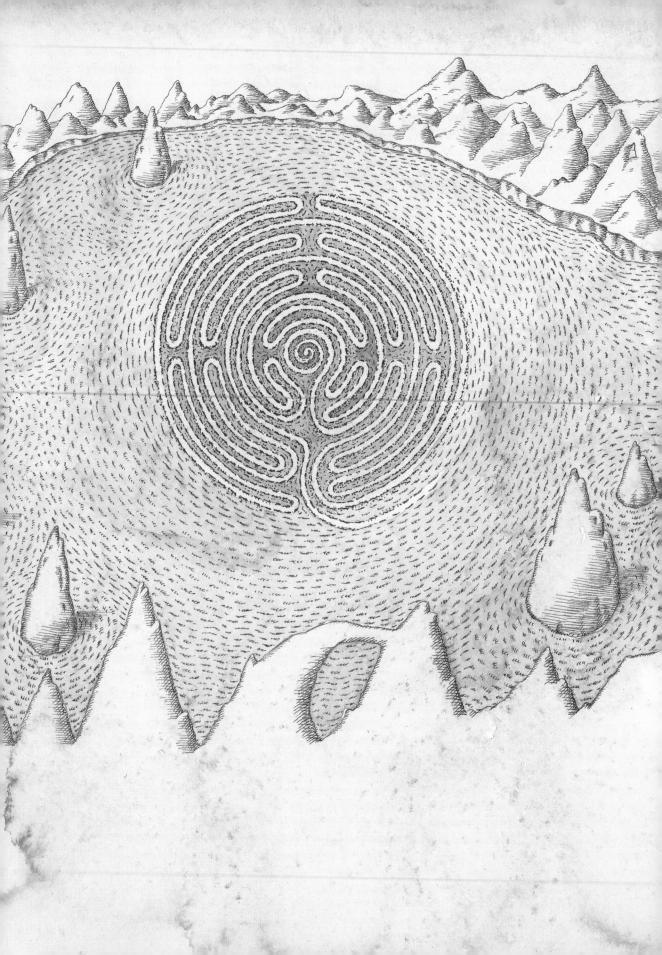

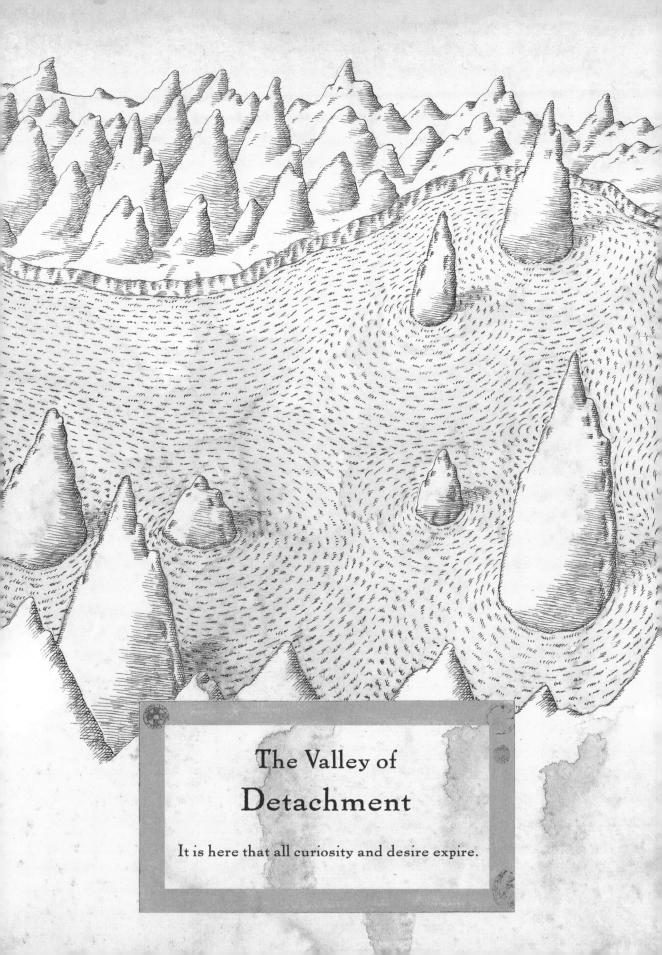

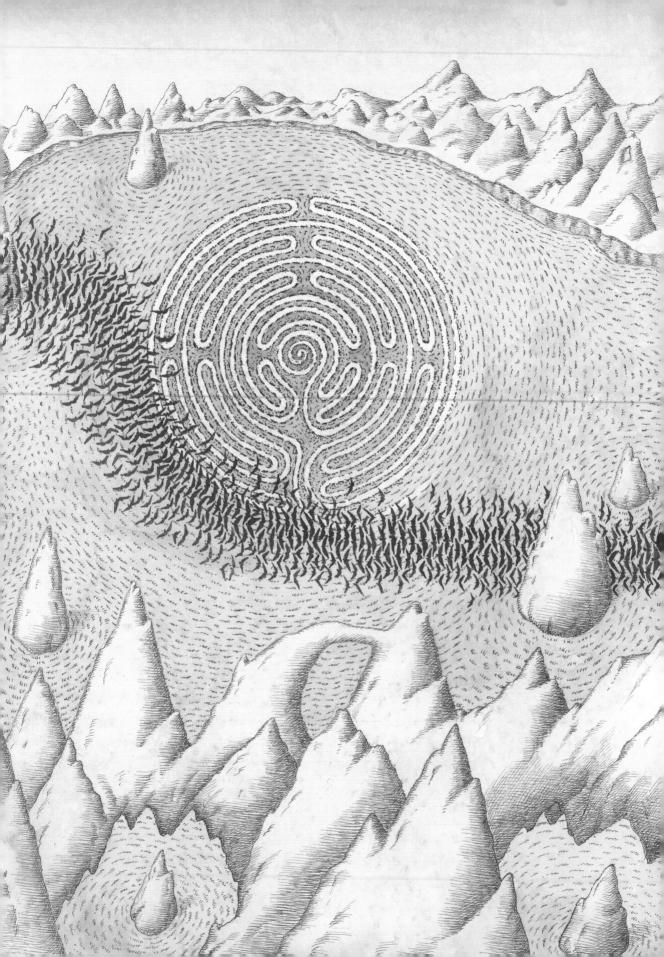

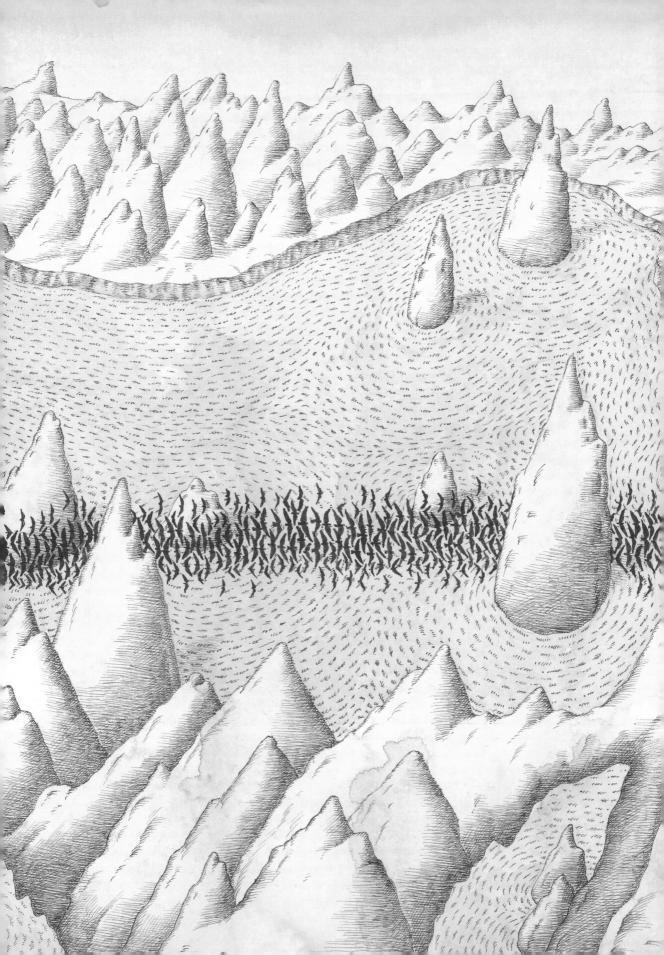

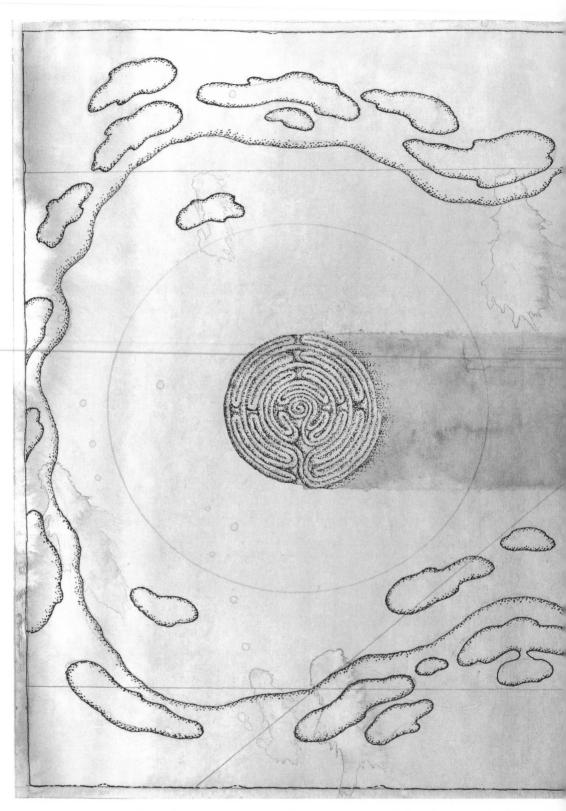

Howling, a tornado surges suddenly out of

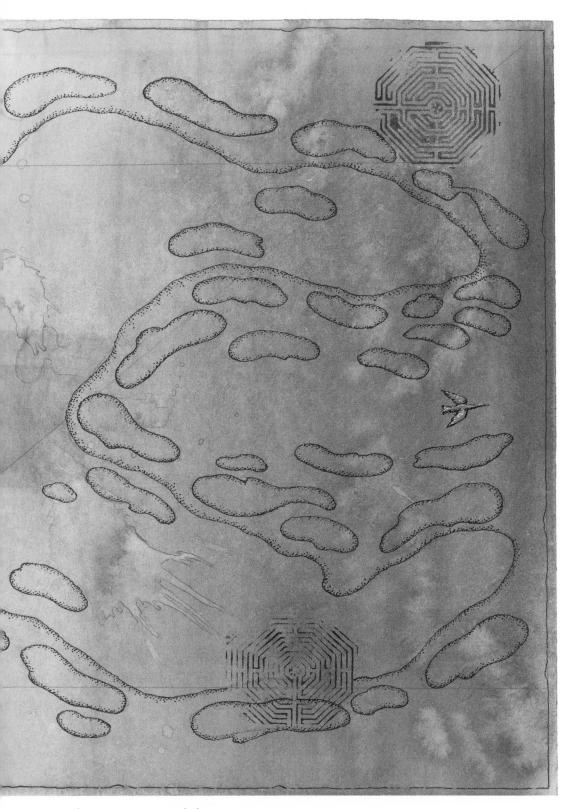

nothingness and lays waste entire continents.

If all the heavens with all their stars exploded in this valley, they would be but a leaf fluttering in the wind.

Here a tiny fish is mightier than a whale and nobody can say why.

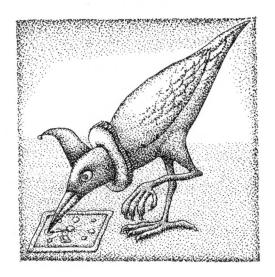

The astrologer bird traces all the constellations and planets on his tablet of sand.

Then the wind picks up and... scatters his design to dust.

How solid is our world... and yet it is nothing but grains of sand.

Hoopoe: Do not even think about stopping here, birds.

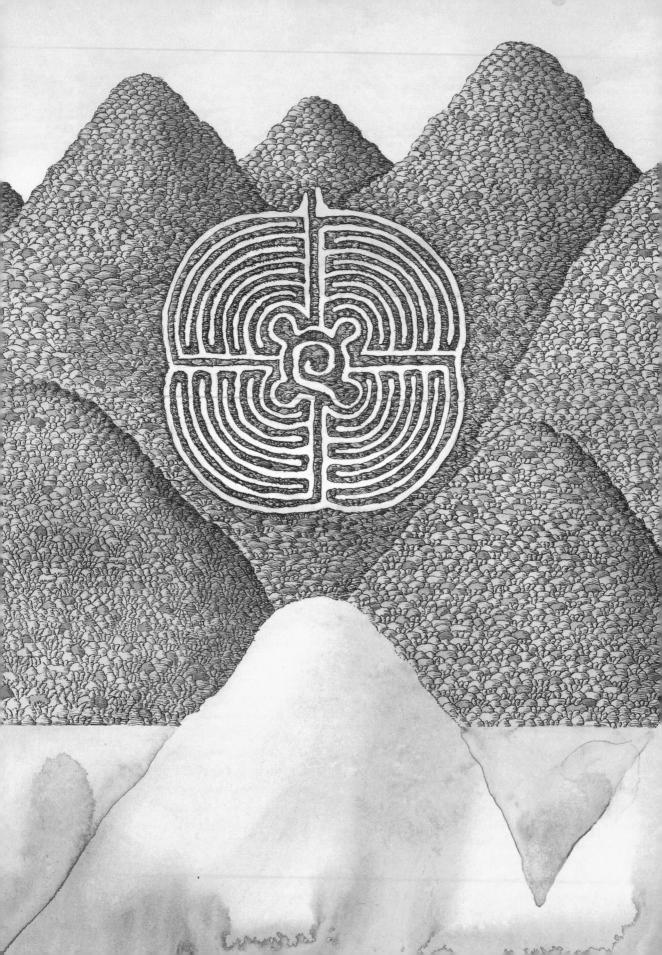

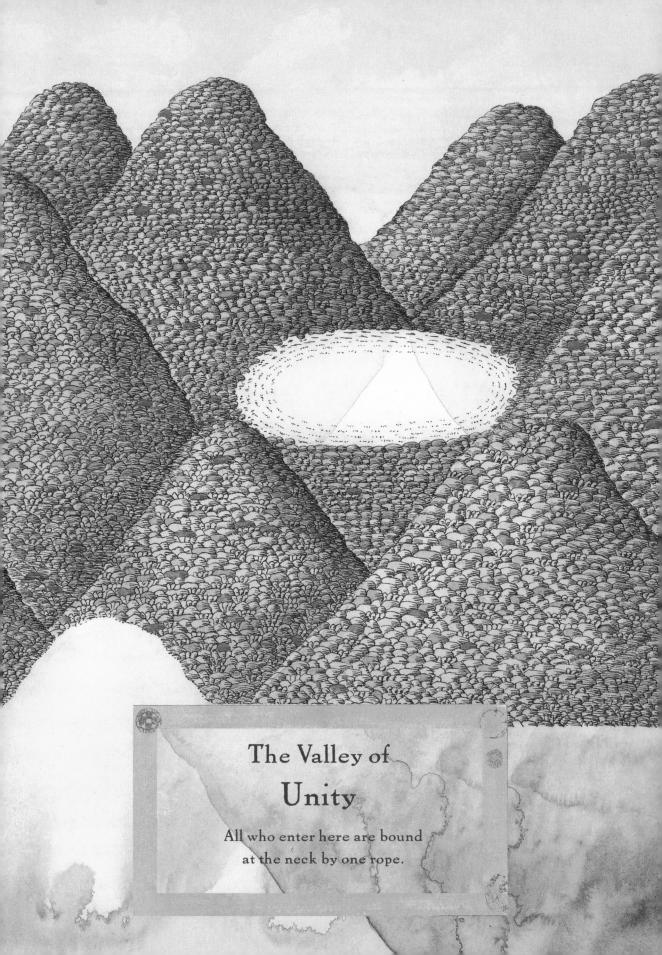

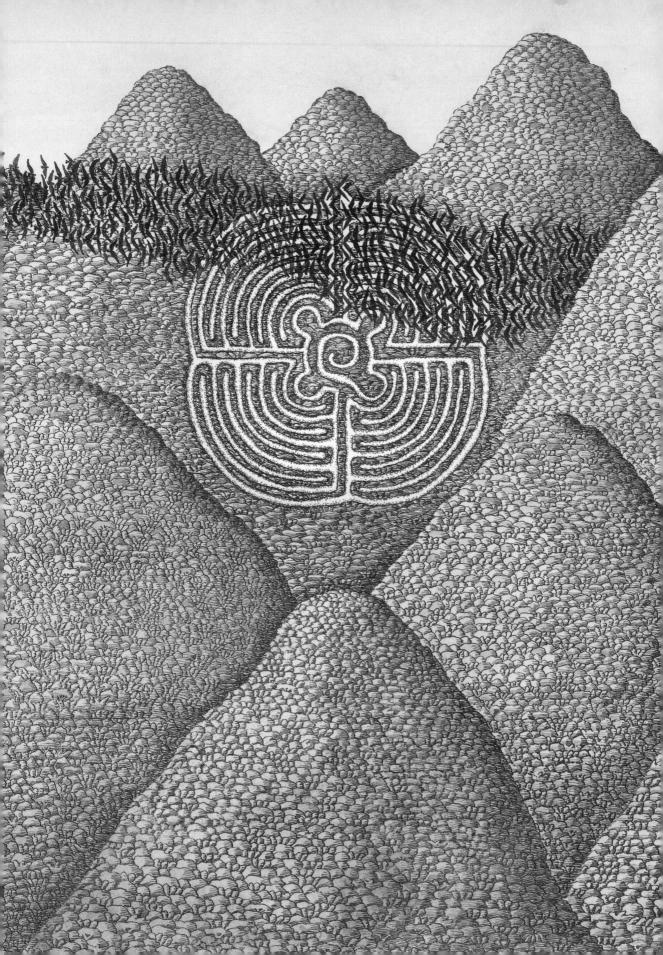

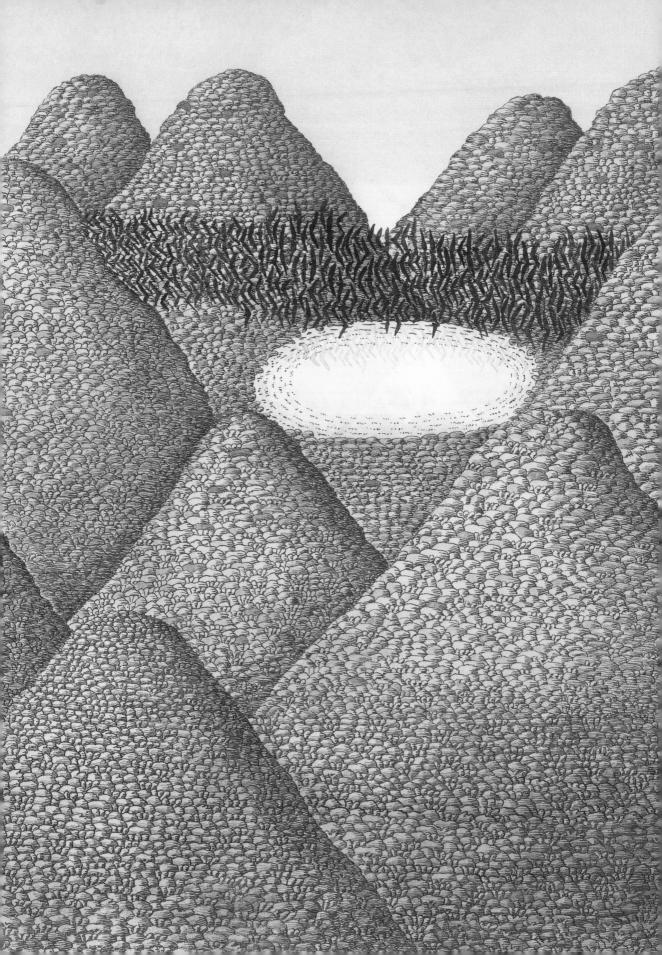

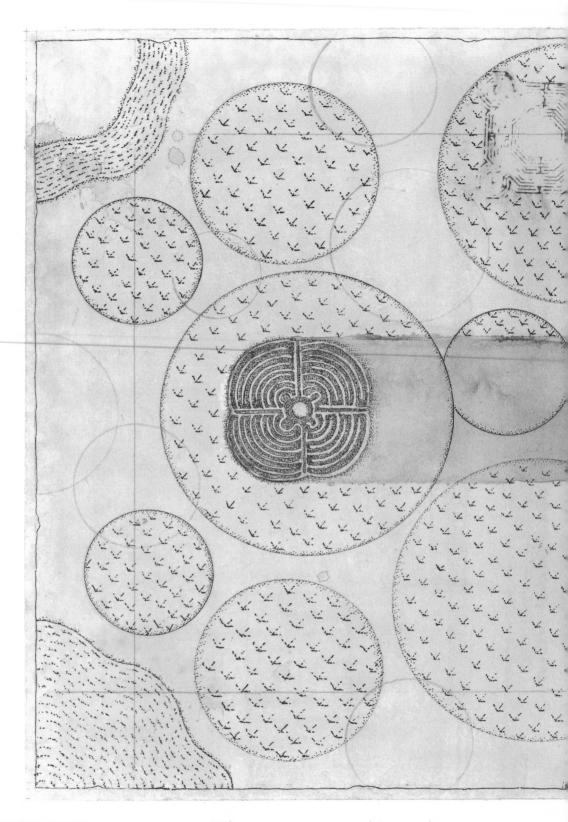

If you see many here, they are in

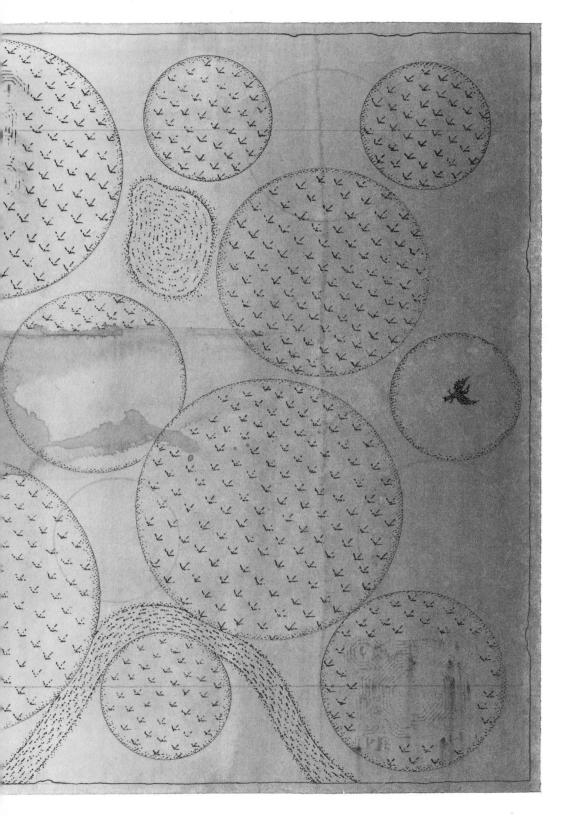

reality only a few...if any.

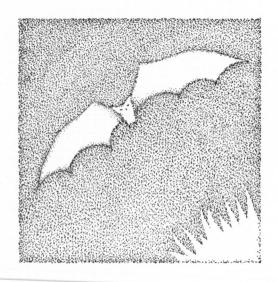

As the exhausted birds drop off to sleep, a bat appears.

Bat: What news do you have of the sun? I've been flying in the dark my whole life.
I can't find the sun.
Does the sun even exist?

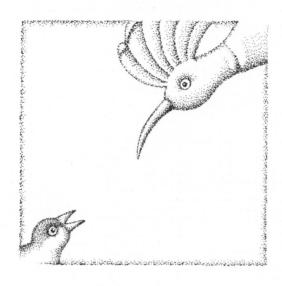

Hoopoe: Why aren't you asleep, tiny bird? We all need our rest.

Tiny bird: I'm never sure of myself.

One day I'm confident and the next day
I'm uncertain. One day I despair, the
next day I soar. I'm weak, I'm frail.
I just...never...fit.

Hoopoe: Everyone has ups and downs, little bird. Fly...clean your heart.

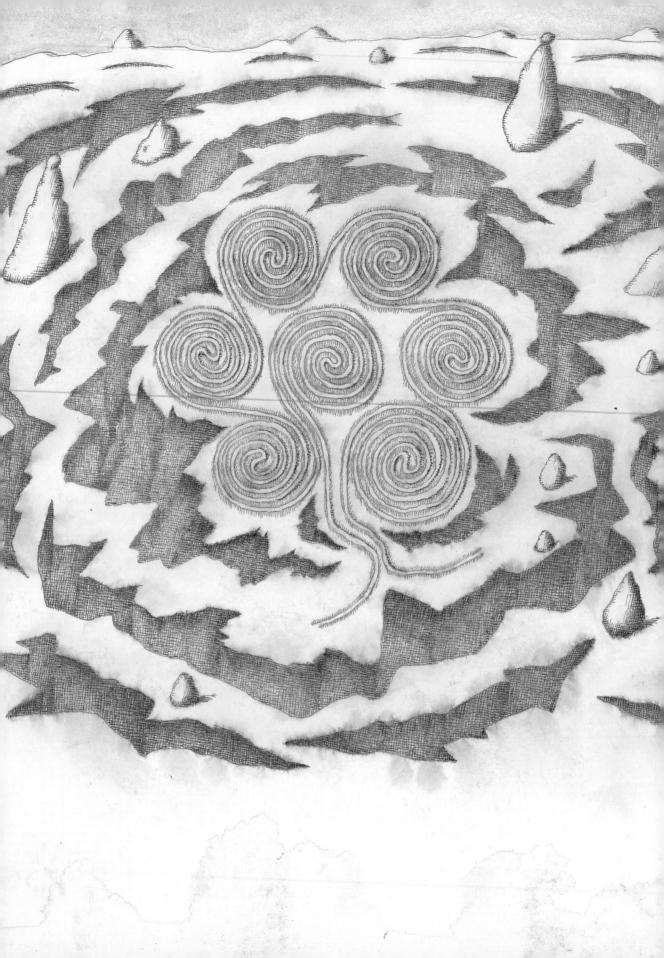

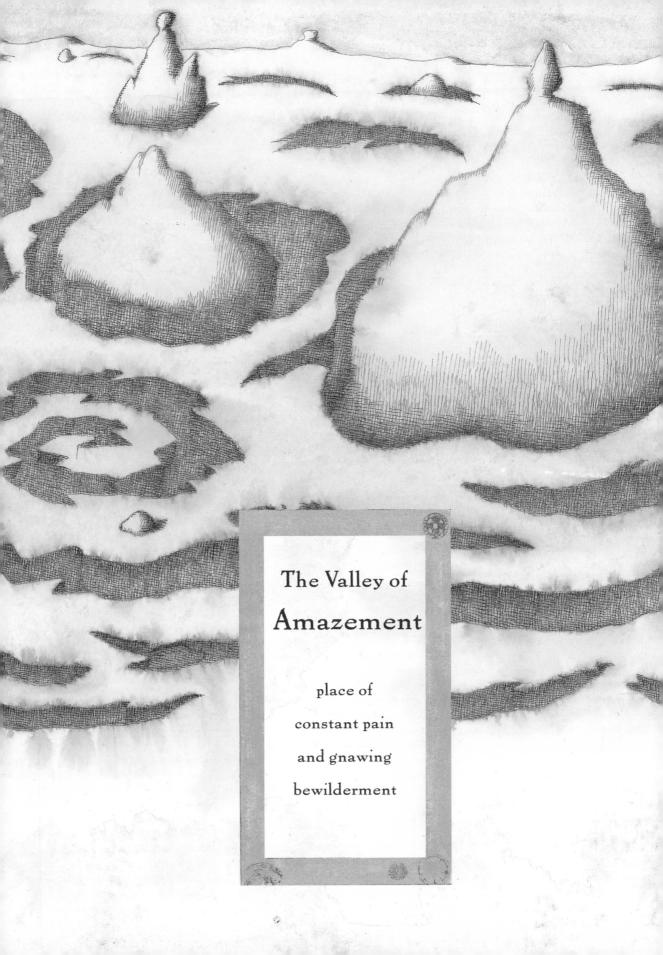

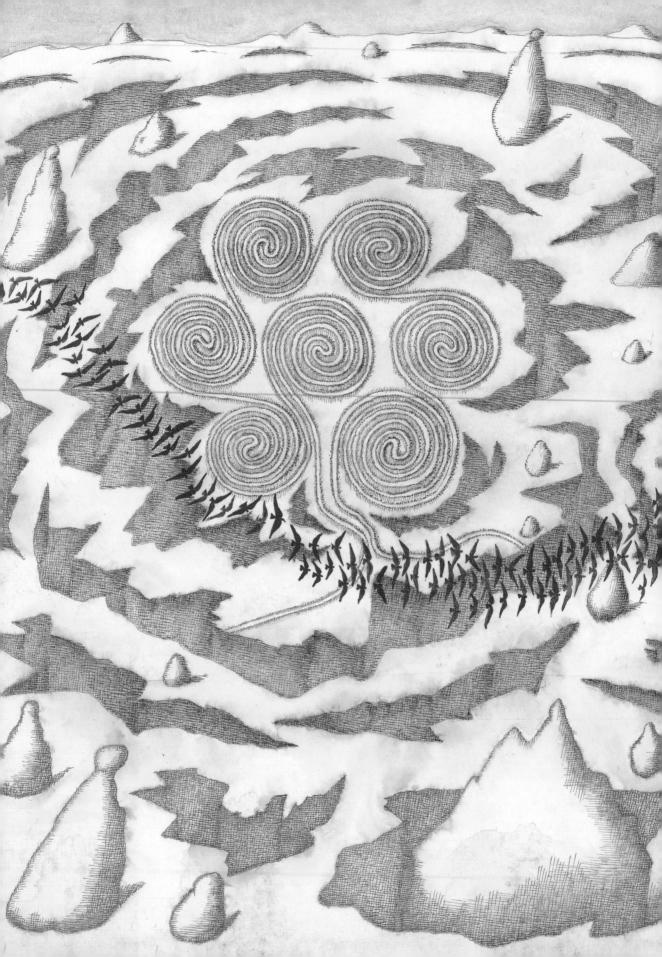

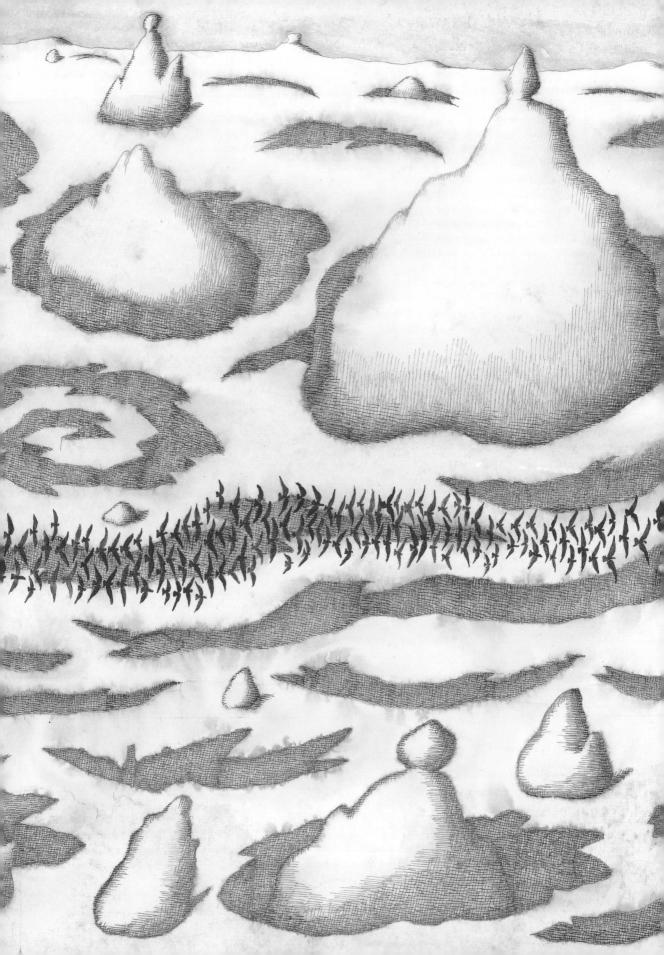

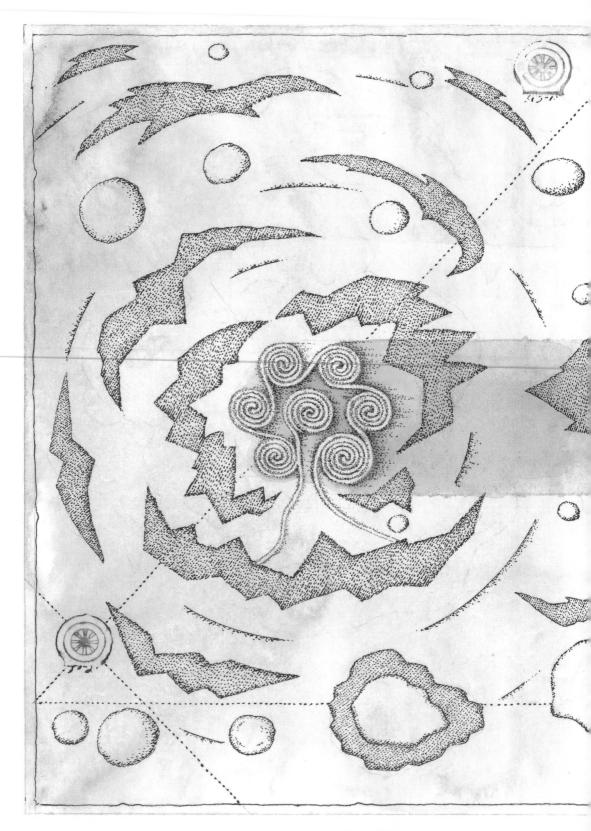

You don't dare to look here...you don't

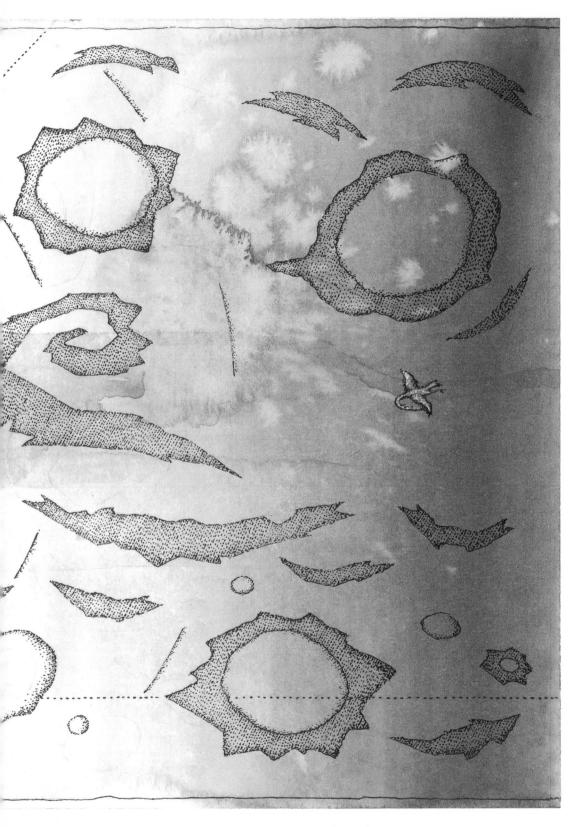

dare to breathe...piercing swords of pain.

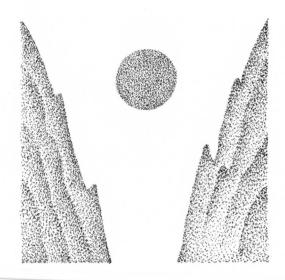

When the birds came to the sixth valley, it disappeared beneath their wings. They were confused... uneasy.

They wondered...they waited.

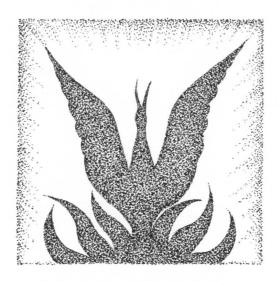

The sorrow bird: We've gone too far. I'm afraid we can't go back.

Hoopoe: Back?...There's a circle, bird.

Why, just think of the phoenix. He lives alone for more than a thousand years acquiring great wisdom and when it's his time to go, he gathers leaves around himself, spreads his wings, and starts a fire—a new phoenix is born from his ashes. We're going forward, bird!

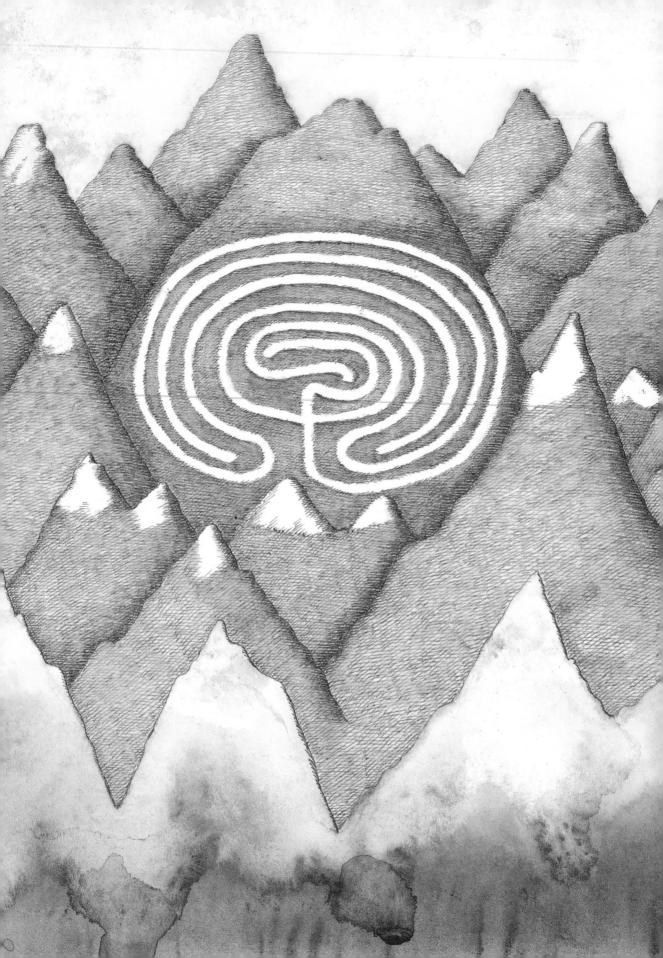

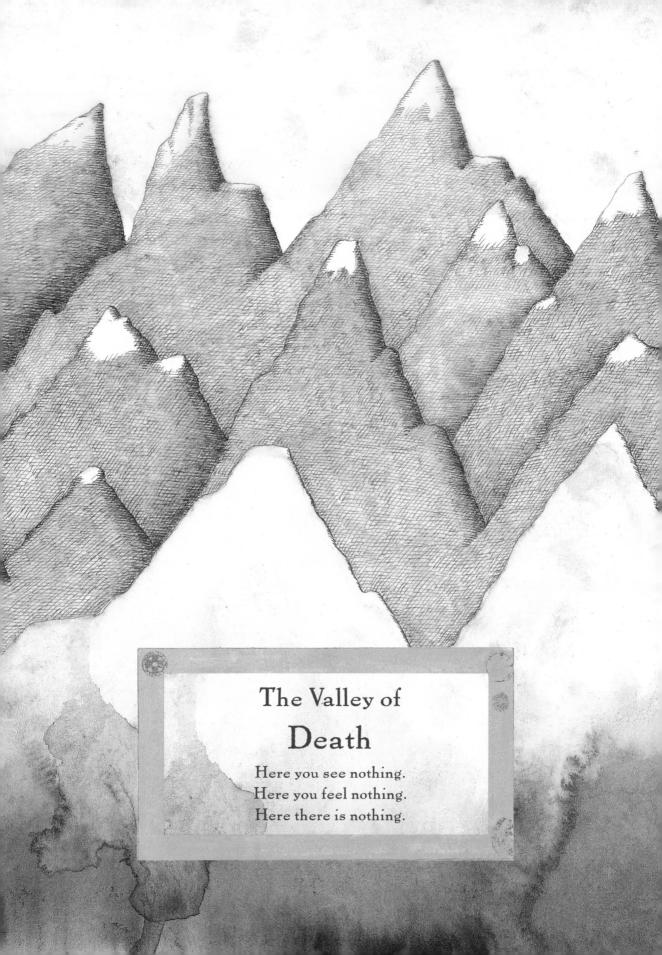

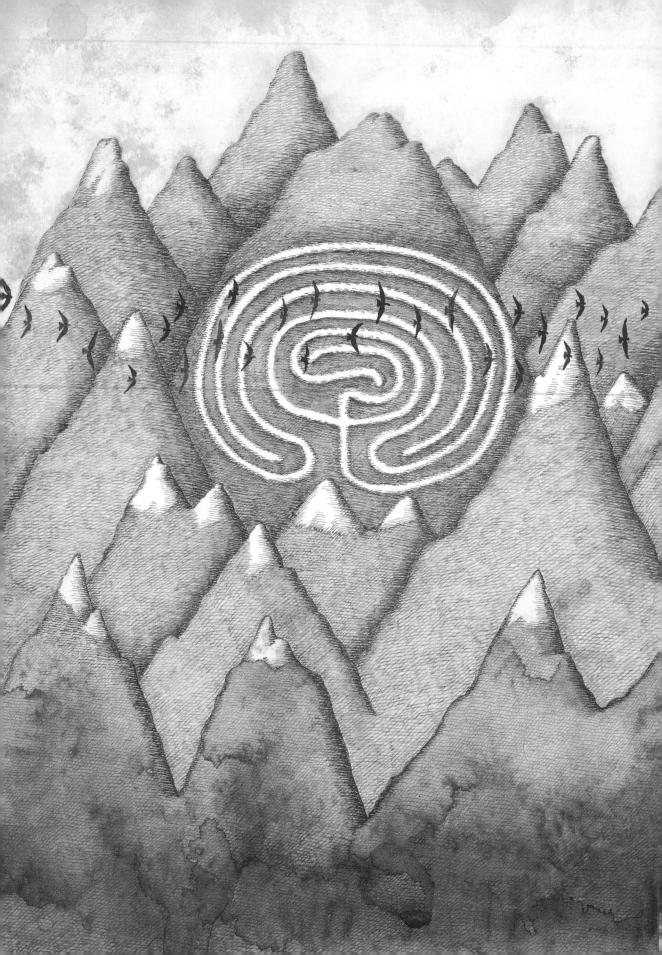

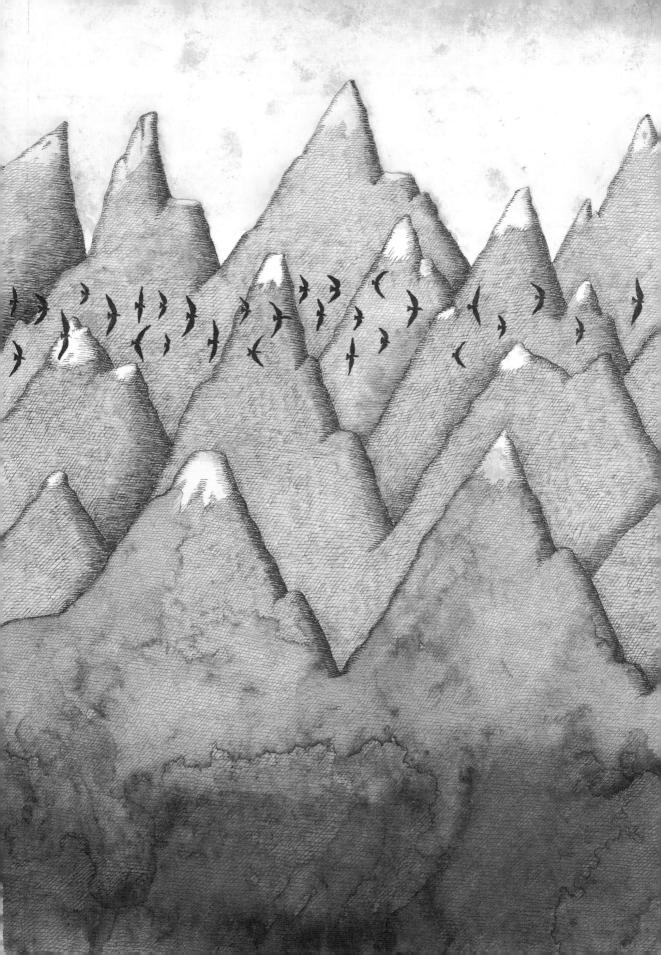

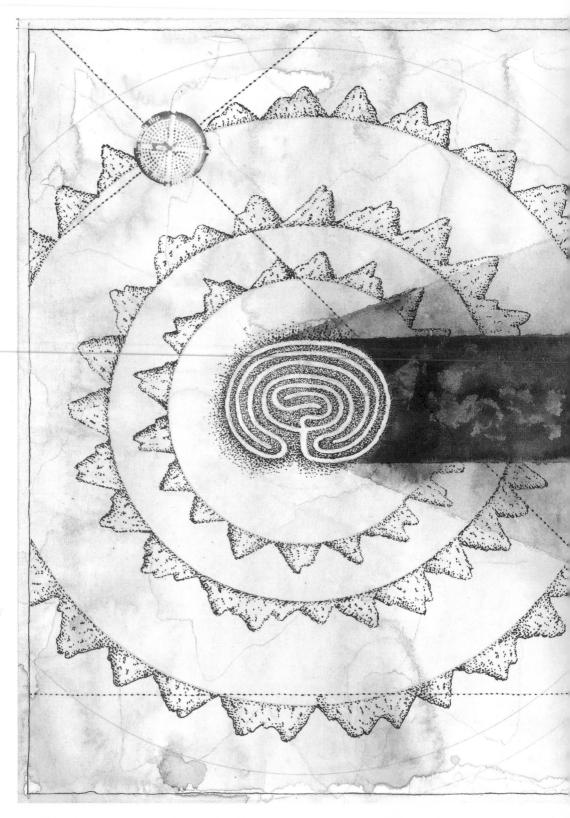

The heart here is still and quiet...

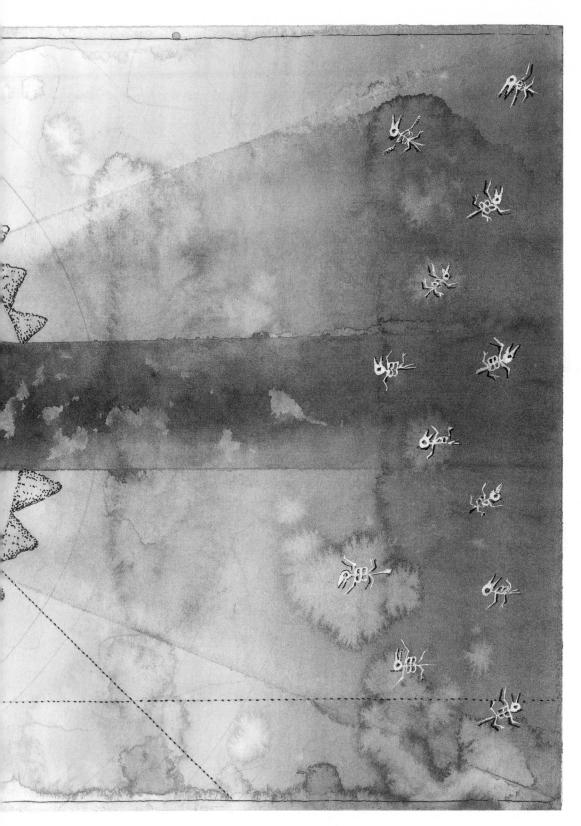

holding many a mystery.

Hundreds of thousands of birds had set off on the journey and they filled all the corners of the world.

But many didn't make it. Some, distressed and discouraged, snuck away in fear. Others kept on going but were overcome. They lost direction, reason, died of thirst, of hunger, from the heat of the sun, from the vastness of the oceans...

They were ravaged by beasts and scared out of their minds by what they saw along the way.

Finally, the remaining ragged birds came to the end of the seventh valley.

BIRDS

Are we alive or dead?

Where is that king
with all the answers?

We've come all this way.

Let us see him!

We made it through
all those valleys!

НООРОЕ

Valleys?

They were only an illusion, birds, a dream.

We've been through nothing.

We are just now at the beginning of our journey.

On the spot, they lost all hope. Soft birds could not believe it. Dougo de pring. They dropped dead and fell from the sky.

Part V

In which the mountain of Kaf appears in the distance.

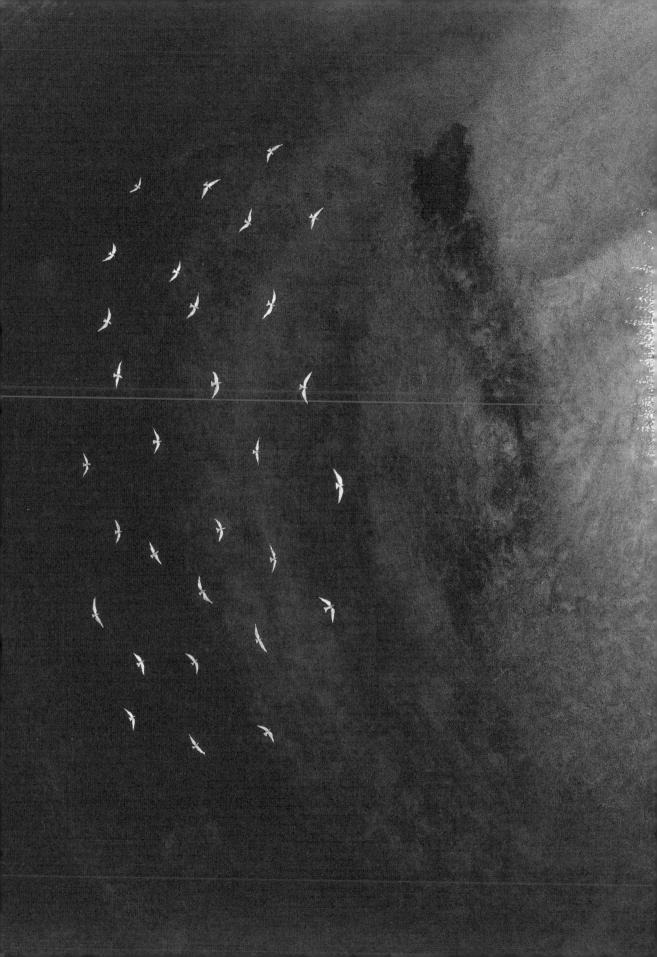

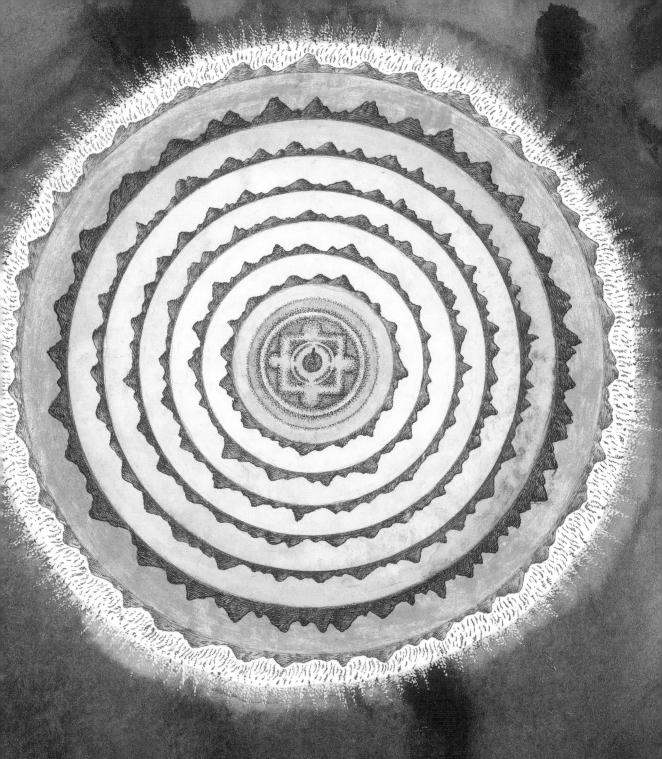

A band of thirty
battered, beaten, beleaguered companions
trying hard not to try and hardly able to fly...

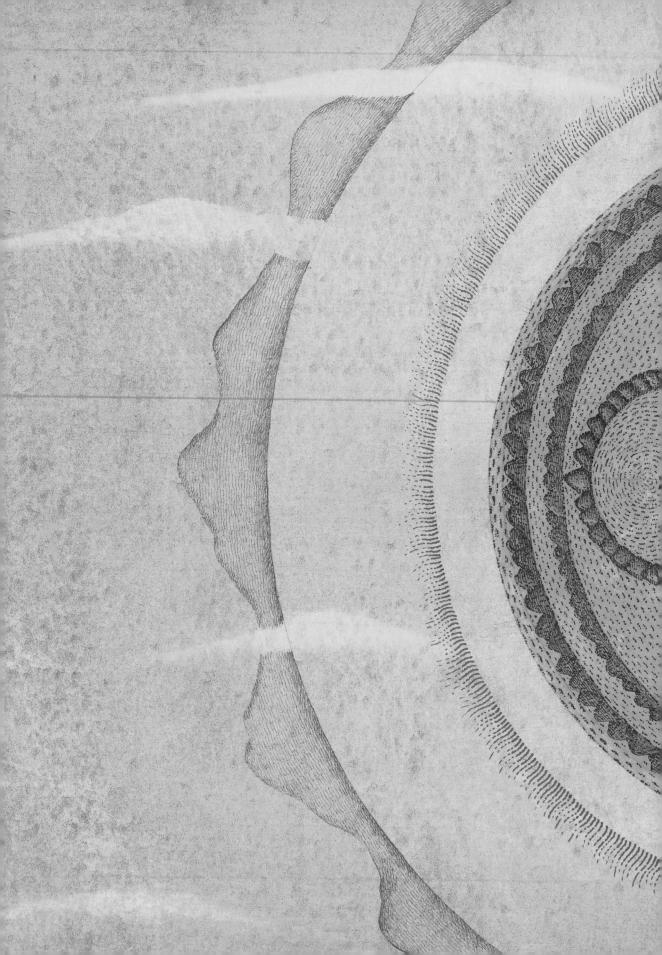

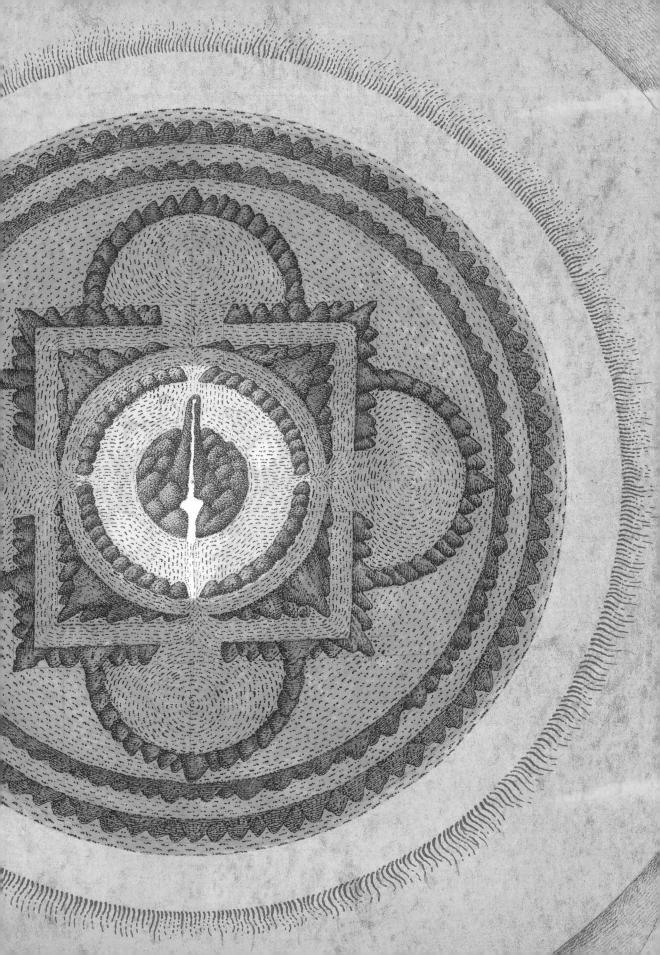

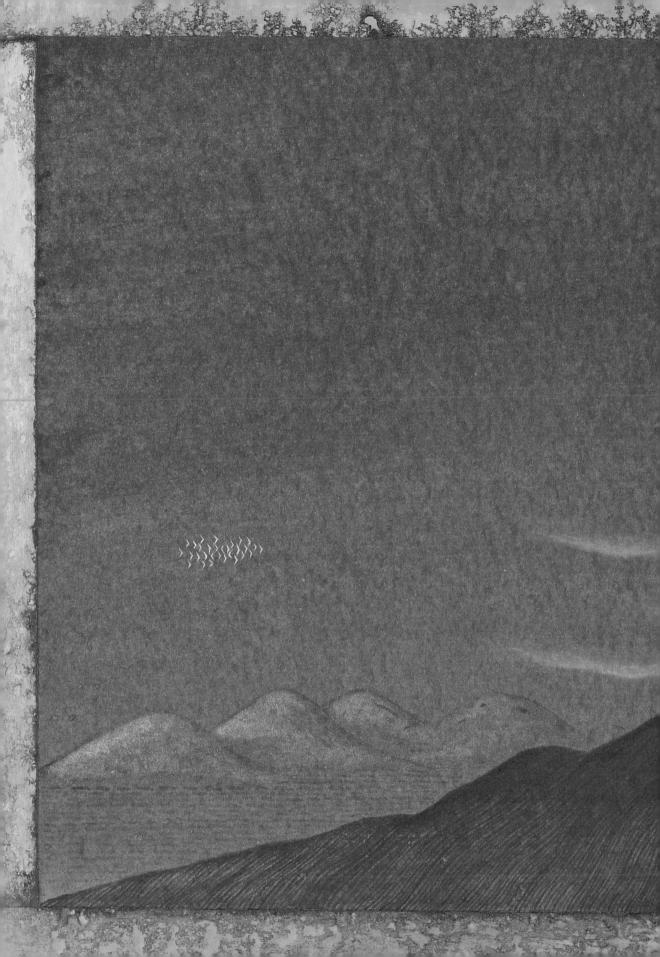

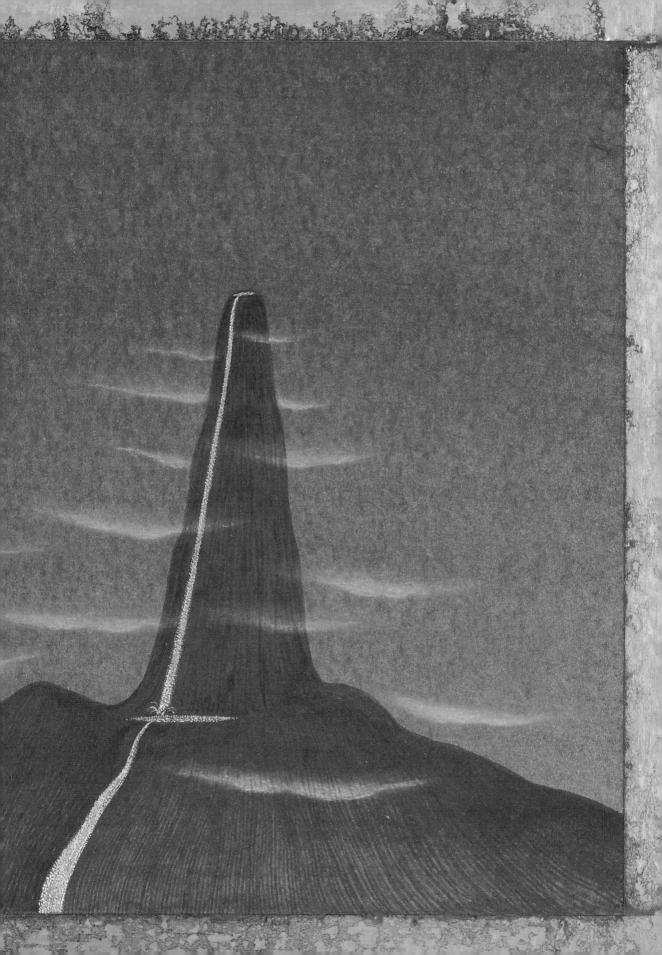

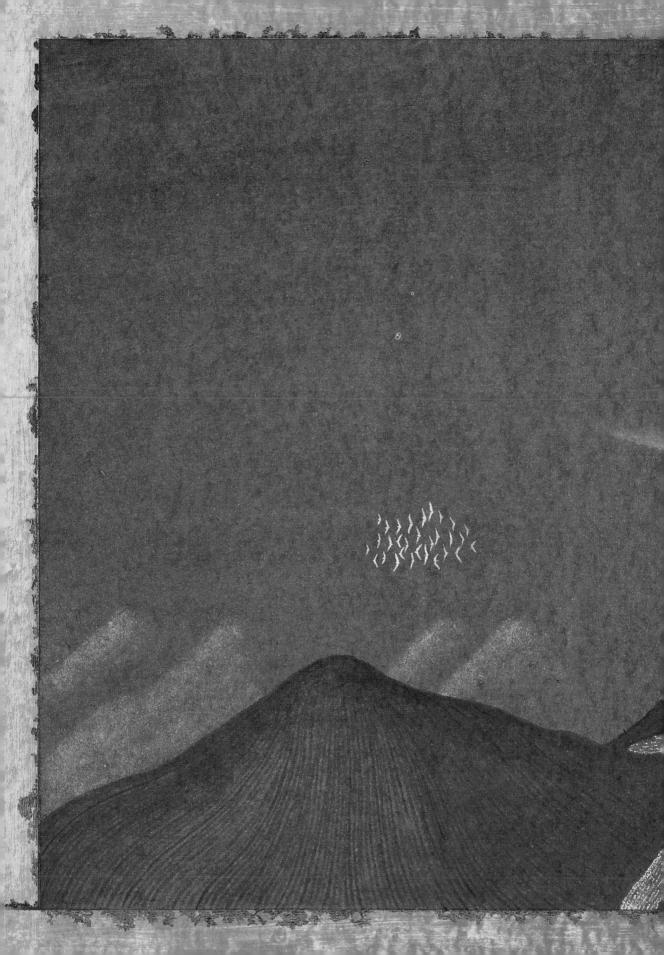

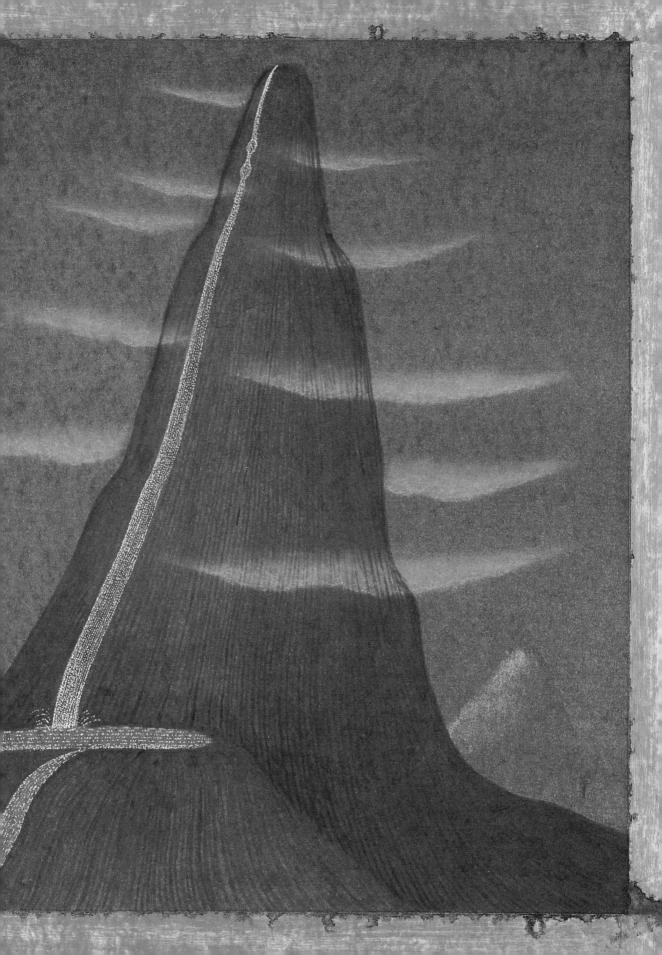

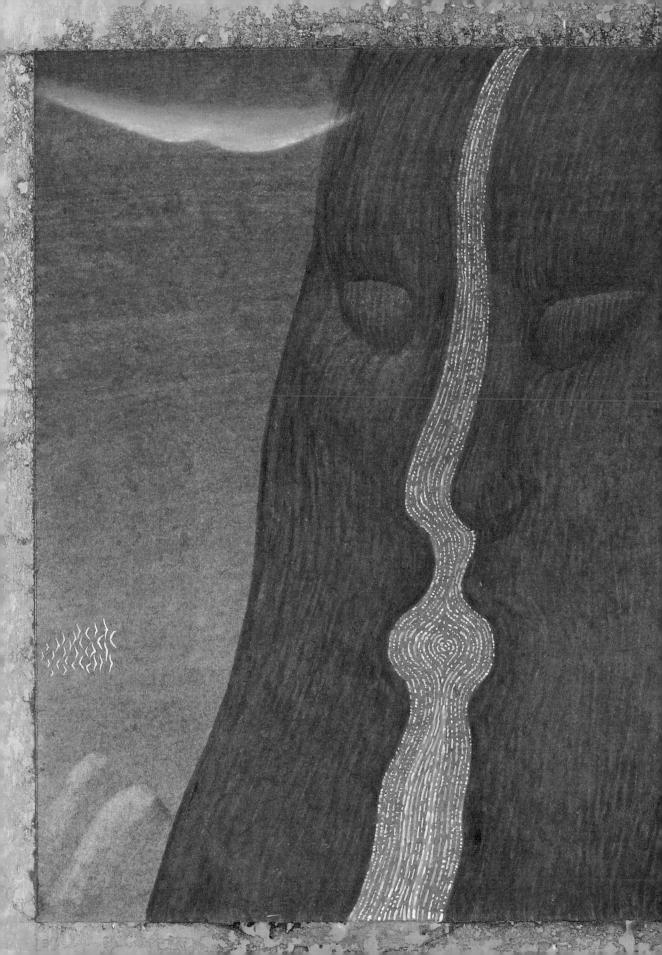

Mountain of Kaf!
We are looking for Simorgh, our king.

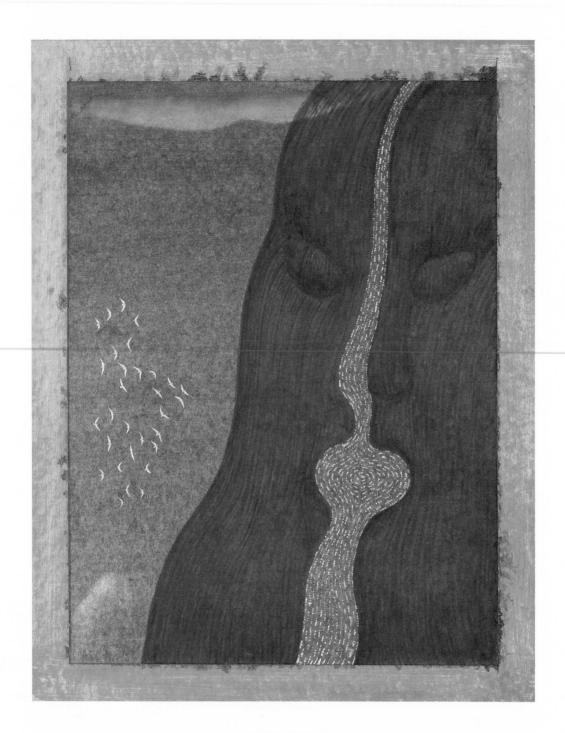

MOUNTAIN

Go home, birds. You are nothing but ashes and dust.

BIRDS

Have pity!

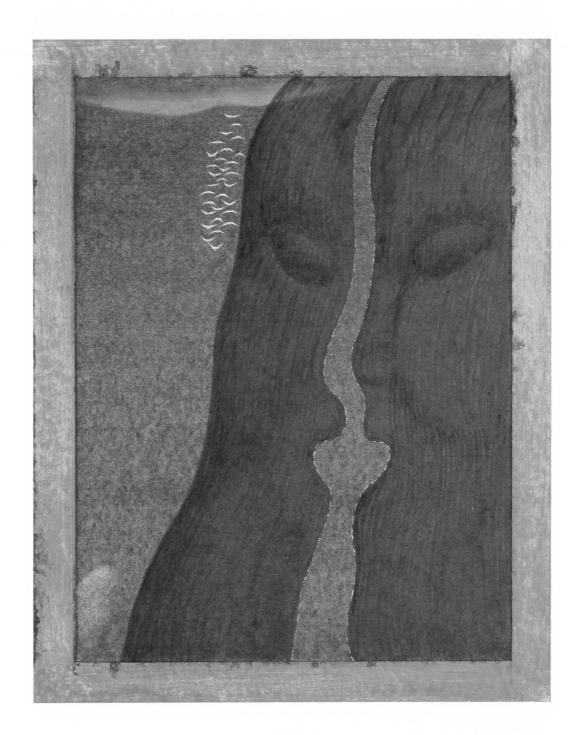

НООРОЕ

Forgive me, birds. I was fooled by my own illusions!

MOUNTAIN

Are you still there? Come!

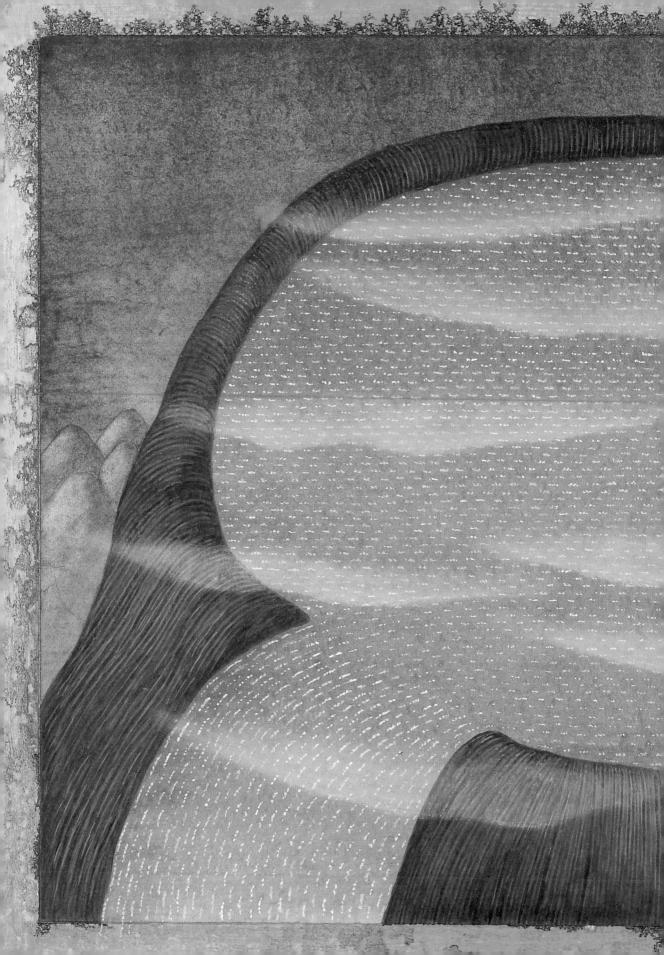

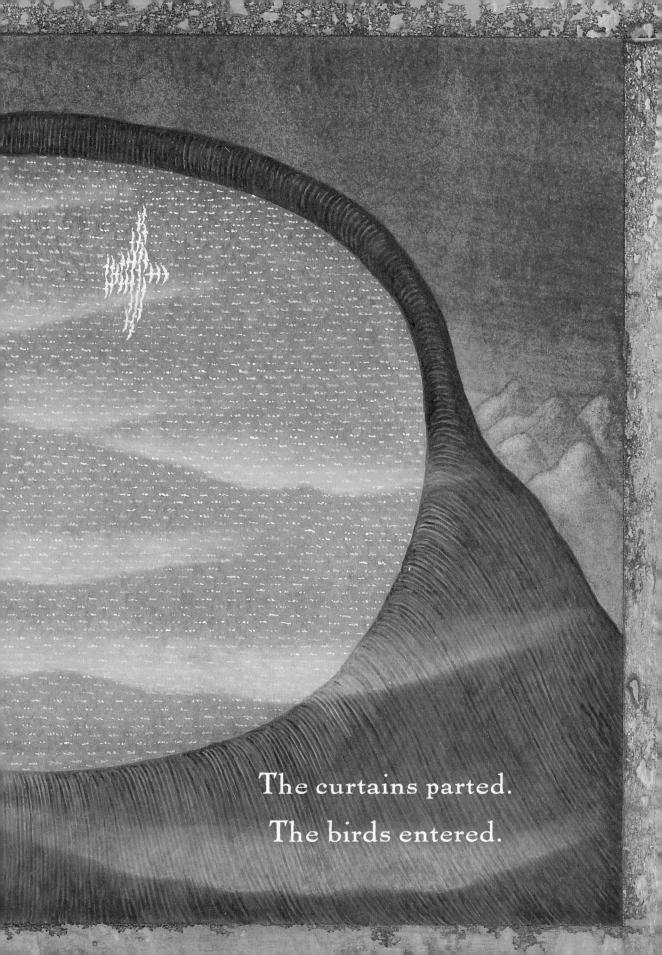

maker restaur resident

小花料

with with wines with and the property of the second second

والمراب ماليان موايد موايد المان المان المان المانية

with looking

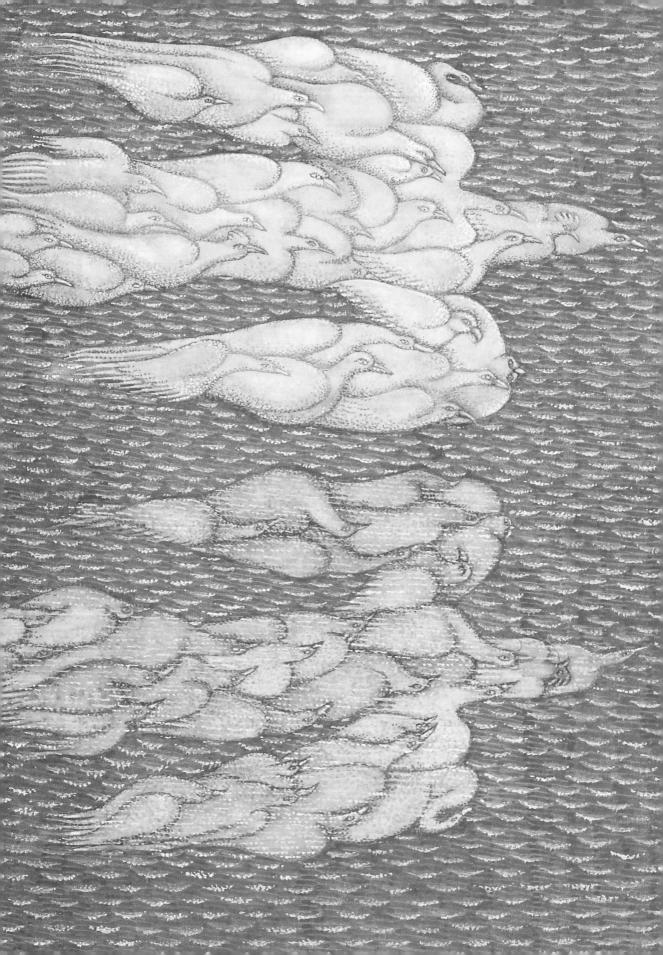

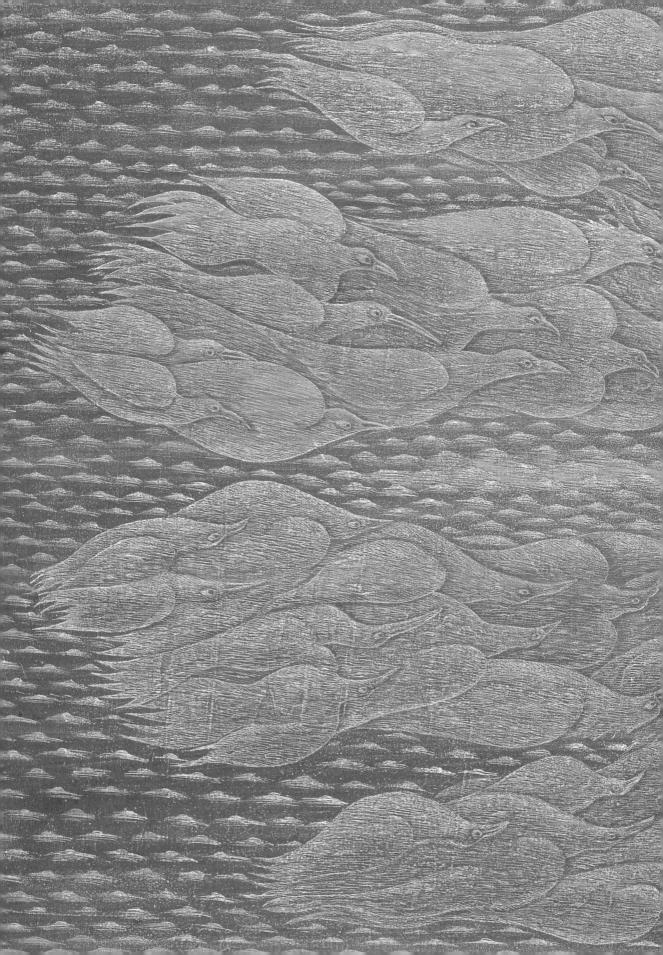

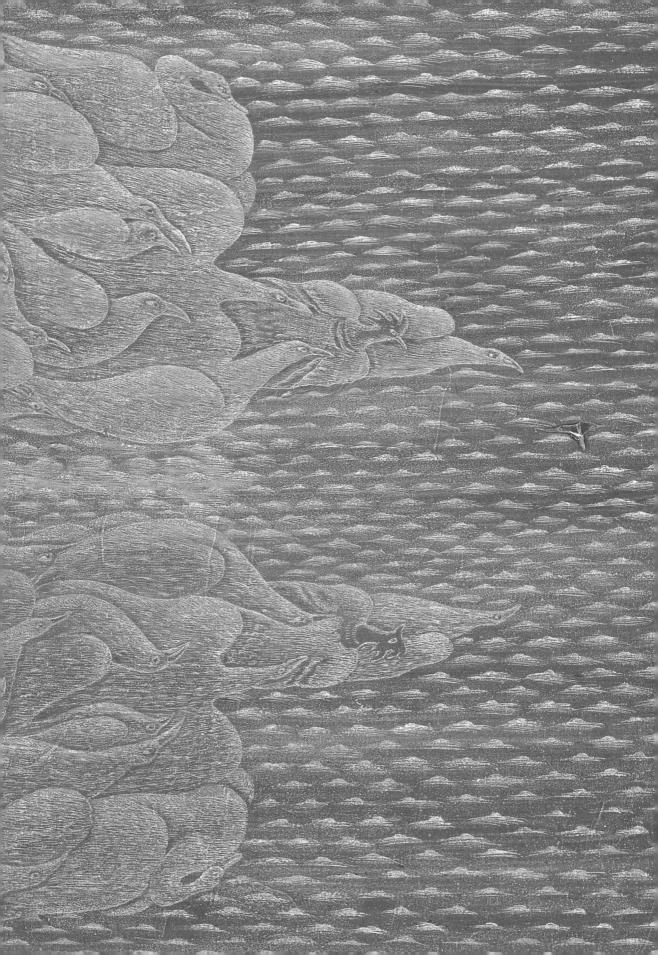

And they saw Simorgh the king

and Simorgh the king was them.

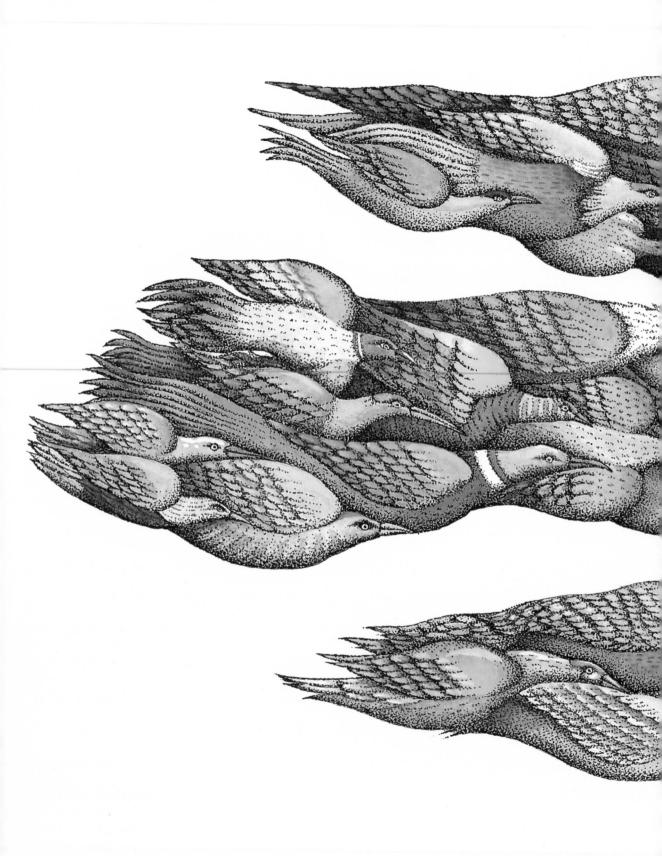

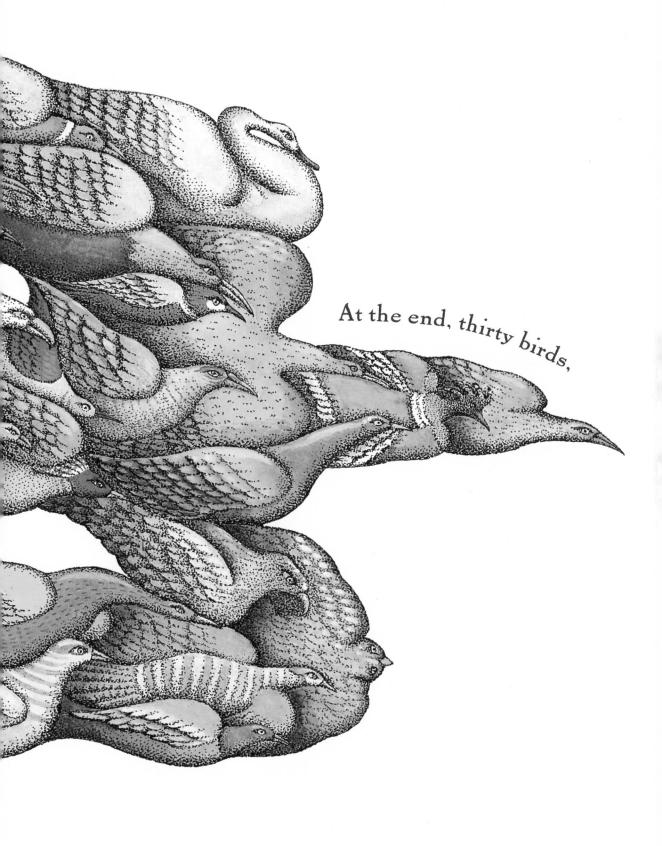

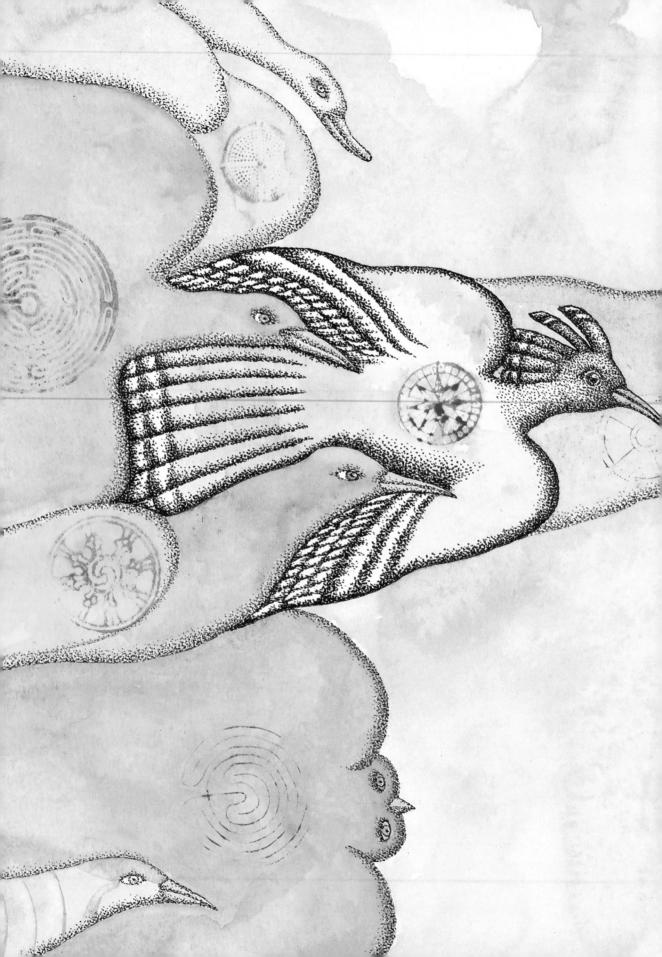

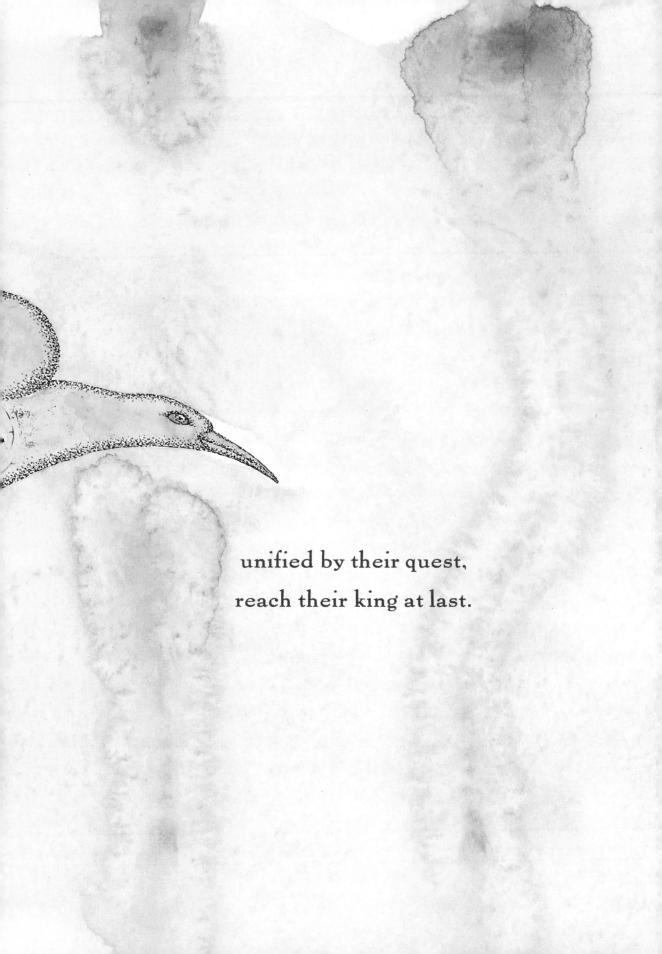

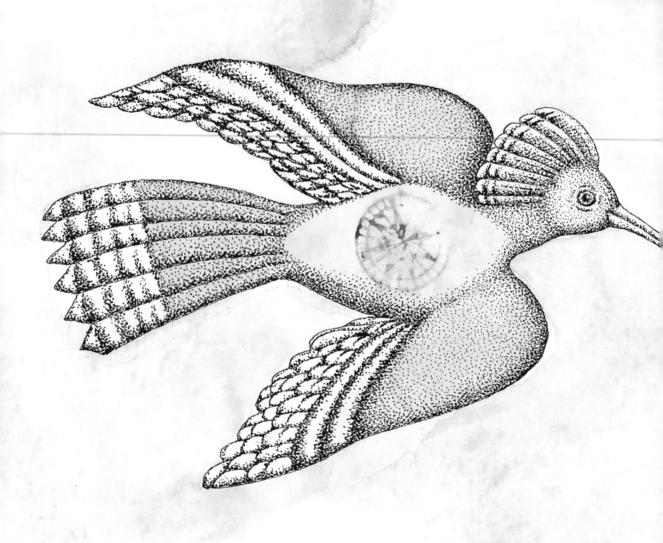

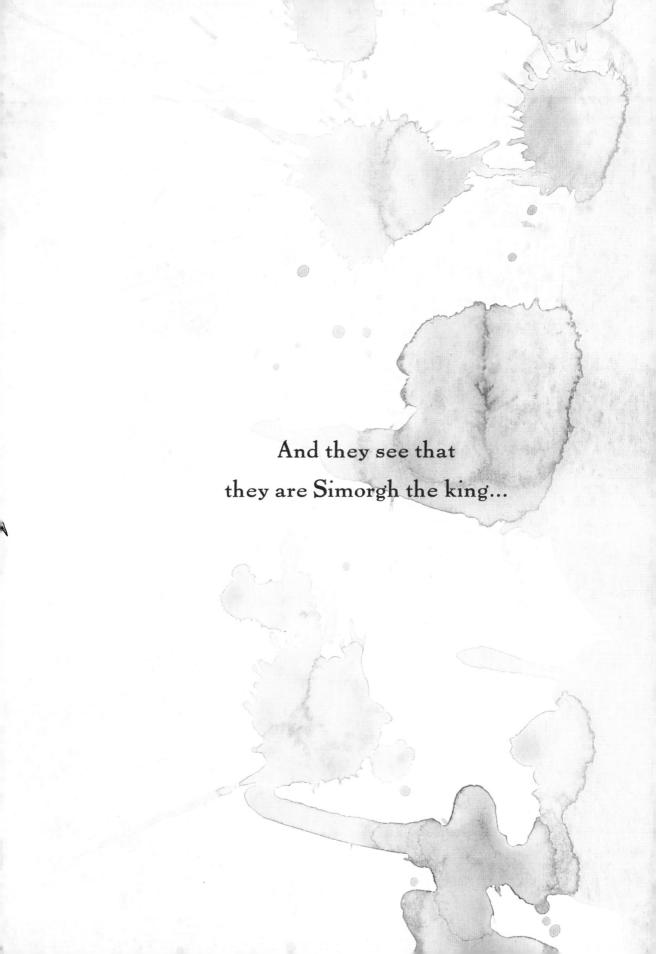

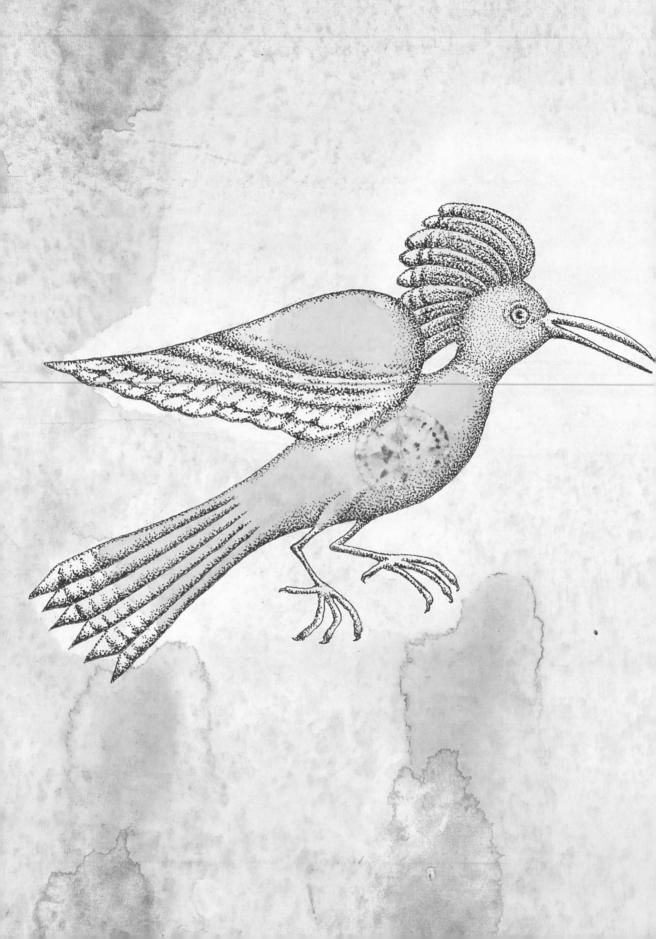

and that Simorgh the king is each of them...

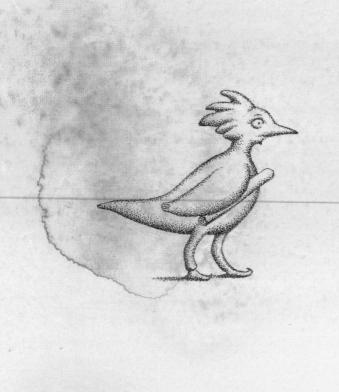

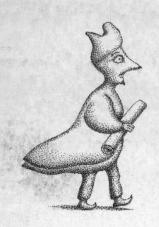

and all of them.

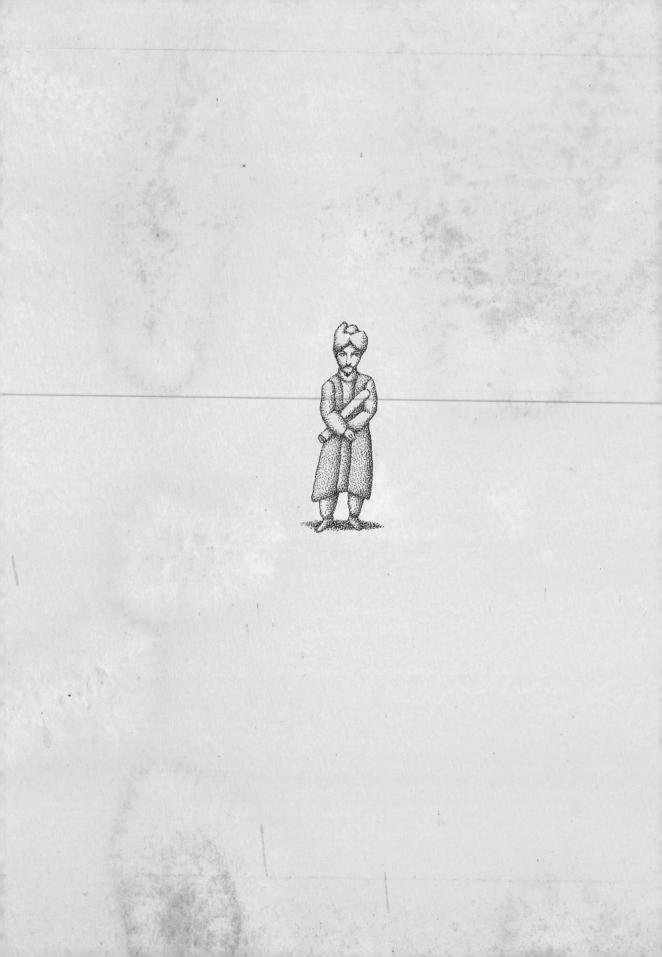

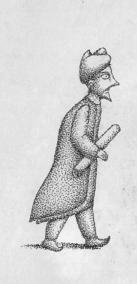

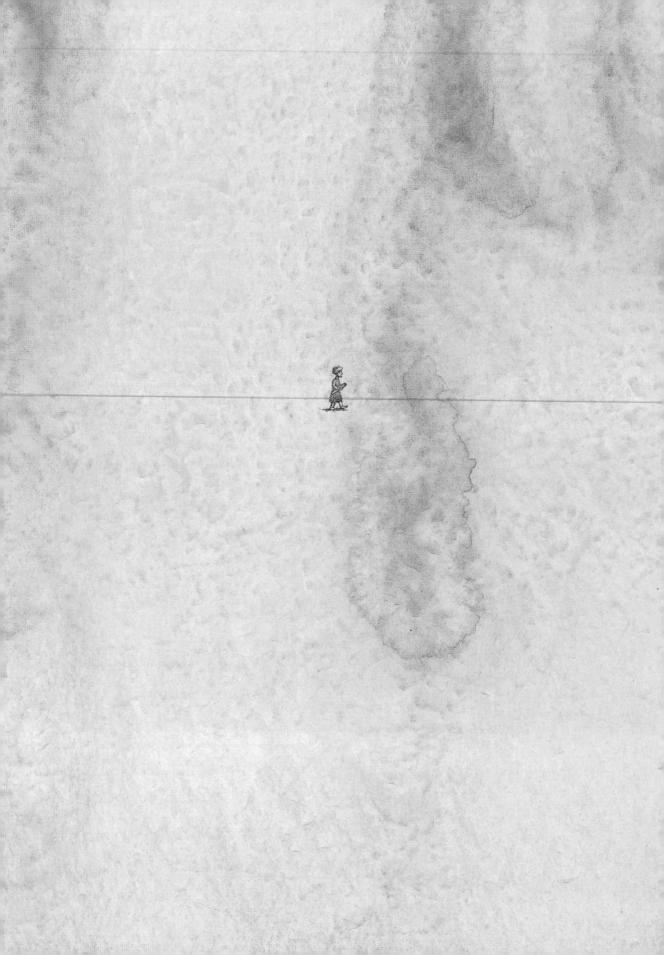

ABOUT THE AUTHOR

Born in Brno, in the former Czechoslovakia, in 1949, Peter Sís is an internationally acclaimed illustrator, author,

and filmmaker. Sis is the author of more than twenty books and is the seven-time winner of The New York Times Book Review Best Illustrated Book of the Year. Most recently, in 2007, he published The Wall: Growing Up Behind the Iron Curtain, which was awarded the Robert F. Sibert Medal and was also named a Caldecott Honor Book. Peter Sis was named a MacArthur Fellow in 2003. He lives in the New York City area with his wife and children.

For more information about Peter Sís and his work, please visit www.petersis.com.

ABOUT THE (ORIGINAL) AUTHOR

Little is known about Farid Ud-Din Attar, but the details we're left with suggest a man who challenged the conventions and ideas of his time.

Attar lived in Nishapur, in northeastern Persia, in the period spanning the late twelfth and early thirteenth centuries. He was known as the Perfumer because he composed his poems in a type of shop-cum-medical dispensary that also sold perfumes. Educated as a theologian, Attar traveled widely: to Egypt, Damascus, and Mecca, and even as far as Turkestan and India. It was said of him that he "never sought a king's favor." In addition to The Conference of the Birds (also known as The "Colloquy" [or "Parliament"] of the Birds), he wrote a "memorial of the saints" in prose.

Attar was tried for heresy and banished, his property looted. In the 1220s, he was back in Nishapur, where he died at the hands of Mongol invaders.

THANKS

For as long as I can remember, I have loved to draw pictures of flying—freedom—and birds. All kinds of birds: human-face birds, fish birds, snake birds. I used them in my animated films, posters, record covers, and illustrations. The story of Simorgh, which I illustrated

in Jorge Luis Borges's Book of Imaginary Beings, was an inspiration. It led me directly to the translation of the original (1177) Mantiq't-Tair by Farid Ud-Din Attar. In turn, Attar—my hoopoe bird—led me through seven valleys of my own:

In the first valley I read Dick Davis and Afkham Darbandi's translation of Attar's 4,500-line epic poem.

In the second valley Zuzana Křížová shared with me her knowledge of all things Persian.

In the third valley my friend and mentor Miloš Forman mentioned that he had seen an amazing play, based on the poem, by his friend Jean-Claude Carrière and Peter Brook.

In the fourth valley Scott Moyers set my birds on an unerring course.

In the fifth valley Ann Godoff welcomed them.

In the sixth valley Claire Naylon Vaccaro shaped their world.

In the seventh valley Veronica Windholz gave my birds a song.

Now I hope to get to the mountain of Kaf—and I hope that it is as relevant today as was Attar's masterpiece centuries ago.

AMERICAN DOCUMENTS

The Bill of Rights

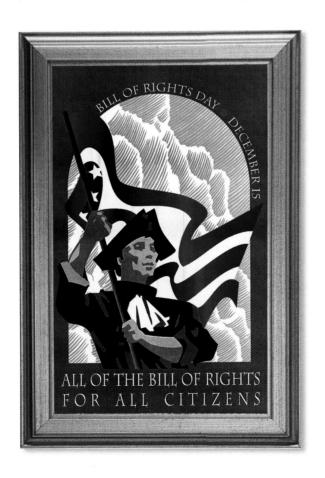

Judith Lloyd Yero

06/06/21 B+T 15.95/8.85 Manufacturing and Quality Management **Picture Credits** Christopher A. Liedel, Chief Financial Officer; Phillip L. Schlosser, Cover (flag) Photodisc/Getty Images: cover (document), 7 courtesy Director; Clifton M. Brown, Manager. Library of Congress; cover (foreground) Joseph Sohm/ChromoSohm Inc/Corbis; p. 1 Courtesy of JPFO.org; pp. 2-3, 14 Flip Schulke/Corbis; Consultants/Reviewers p. 4 AFP/Corbis; pp. 4-5 Todd A. Gipstein/Corbis; pp. 6, 13, 17, 22, Dr. Paul Finkelman, Chapman Distinguished Professor of Law, 24 AP Wide World Photos; pp. 8, 16, 19, 26 Bettmann/Corbis; University of Tulsa Law School, Tulsa, Oklahoma pp. 9-11, 25 (top) Corbis; pp. 12 (top), 13 (bottom) Hulton Dr. Margit E. McGuire, School of Education, Seattle University, Archive/Getty Images; p. 12 (bottom) Historical Society of the Court of Seattle, Washington New York; pp. 15, 25 (bottom), 29 David Butow/Corbis SABA; p. 18 **Book Development** Leif Skoogfors/Corbis; p. 20 PhotoEdit Inc.; p. 21 Royalty-Free/Corbis; Nieman Inc. p. 23 Mark Peterson/Corbis; p. 27 Reuters New Media/Corbis; p. 28 Wally McNamee/Corbis; p. 30 Michael Yamashita/Corbis; p. 31 Swim **Book Design** Ink/Corbis. Printed by permission of the Norman Rockwell Family Steven Curtis Design, Inc. Agency. © 1943 The Norman Rockwell Family Entities. Art Direction Produced through the worldwide resources of the National Geographic Dan Banks, Project Design Company Society, John M. Fahey, Jr., President and Chief Executive Officer; Photo Research Gilbert M. Grosvenor, Chairman of the Board: Nina D. Hoffman. Corrine L. Brock, In the Lupe, Inc. Executive Vice President and President, Books and Education Copyright © 2006 National Geographic Society. All Rights Reserved. Publishing Group. Reproduction in whole or in part of the contents without written Prepared by National Geographic School Publishing and permission from the publisher is prohibited. Children s Books ISBN 0-7922-5395-7 (hardcover) Ericka Markman, Senior Vice President and President, Children's Books and Education Publishing Group; Steve Mico, Vice President, ISBN 0-7922-5396-5 (library binding) Editorial Director: Marianne Hiland, Executive Editor: Anita Schwartz, Previously published as Documents of Freedom: The Bill of Rights Project Editor, Suzanne Patrick Fonda, Children's Books Project Editor; (National Geographic Reading Expeditions). Copyright © 2004 Jim Hiscott, Design Manager; Kristin Hanneman, Illustrations Manager; ISBN 0-7922-4552-0 (paperback) Diana Bourdrez, Picture Editor; Matt Wascavage, Manager of Publishing Services; Sean Philpotts, Published by the National Geographic Society Production Manager. 1145 17th Street, N.W. Washington, D.C. 20036-4688 Printed in the U.S.A.

On Display Chapter 1 Five Freedoms Chapter 2 Protection Chapter 3 Rights of the Accused Chapter 4 Limits to Power Classary Chapter 4 Limits to Power Classary Chapter 5 Rights Chapter 6 Limits to Power Chapter 7 Rights Chapter 7 Rights Chapter 8 Limits to Power Chapter 9 Limits to Power Chapter 9 Rights Chapter 9 Rights Chapter 1 Five Freedoms Chapter 1 Five Freedoms Chapter 2 Protection Chapter 2 Protection Chapter 3 Rights Chapter 3 Rights Chapter 3 Rights Chapter 4 Limits to Power Chapter 6 Chap		Table of Contents Introduction ************************************
Chapter 1 Five Freedoms ************************************		
Chapter 2 Protection ************************************		
Chapter 3 Rights of the Accused ************************************		
Chapter 4 Limits to Power ************************************		
Glossary ************************************		
The Bill of Rights ************************************		경영 그 사람이 그는 사람들은 사람들은 항상 하는 경영에 없는 경기에서 그는 사람들이 되었다. 이 경영성 그 사람들에서는 사라를 가장 하는 것으로 보고 있다. 그 나는 사람들이 없다.
The Declaration of Rights of the Stamp Act Congress ** * * 34 The Virginia Declaration of Rights ** ** ** ** ** * * * * * * * * * * 36 Miranda Rights ** ** ** ** ** ** * * * * * * * * * *	11/2	
The Virginia Declaration of Rights ************************************		#10 / B #15 / B
		The Virginia Declaration of Rights ************************************
Index ************************************		Miranda Rights * * * * * * * * * * * * * * * * * * *
		Index ********* 40
		Harrist with the same of the s
	- n	
	STATE OF THE PARTY NAMED IN	

Col State

1

Introduction

Imagine what your life would be like if:

- You could be arrested for writing things government officials didn't like.
- The police could search you and take away your property—for no reason you could figure out.
- You could be tortured into making a confession and it would be enough evidence to send you to jail.

That is how it is in some countries in the world today. Before the American Revolution, some of those things happened here! It's not that way any more.

The U.S. Constitution is our plan for government. It was written in 1787 to give the states a national government strong enough for the new country to work.

Americans have the right to worship as they choose. Here, leaders of different religions pledge allegiance at an interfaith service.

At first, many people were against the Constitution. They said it made the government too big and too powerful. Many people thought it should have a bill of rights to protect individuals from government abuse. For the Constitution to go into effect, 9 of the 13 states had to ratify, or approve, it. Arguments raged on for nearly a year. Finally, by the summer of 1788, nine states had accepted it. For many people, their "yes" vote came only after they were promised the Constitution would have a bill of rights.

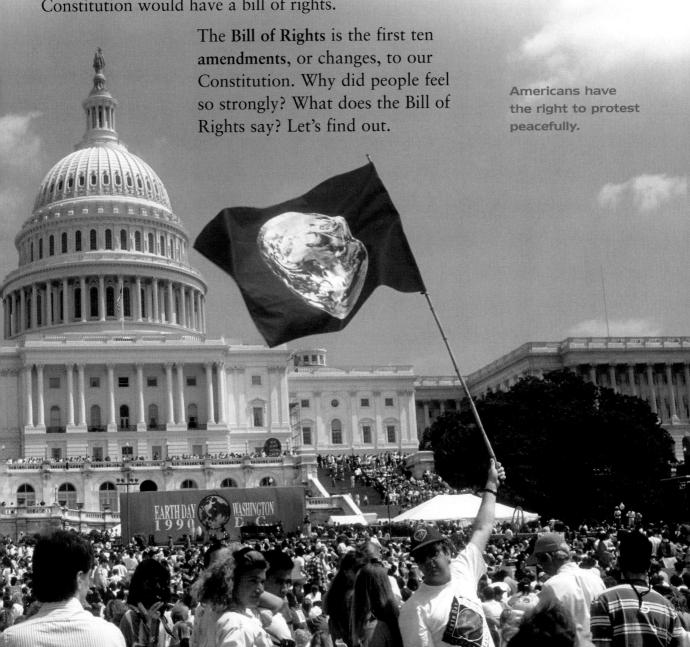

On Display

In 1789, Congress sent the states 12 amendments to approve. By 1791, they had approved ten amendments, now known as the Bill of Rights. Each state got an official copy. Congress had its own copy, which is kept in the National Archives in Washington, D.C.

Who "Wrote" It?

The handwritten copy on display in the National Archives was probably written by William Lambert, an assistant clerk in the House of Representatives.

Who Signed It?

Only four people signed the Bill of Rights: Frederick Augustus Muhlenberg, Speaker of the House of Representatives; John Adams, Vice-President of the United States and President of the Senate; and the chief Senate and House clerks

Which States?

Eleven states ratified the Bill of Rights. Three—Georgia, Connecticut, and Massachusetts—did not. The first state to ratify it was New Jersey, on November 20, 1789. Virginia was the last, on December 15, 1791.

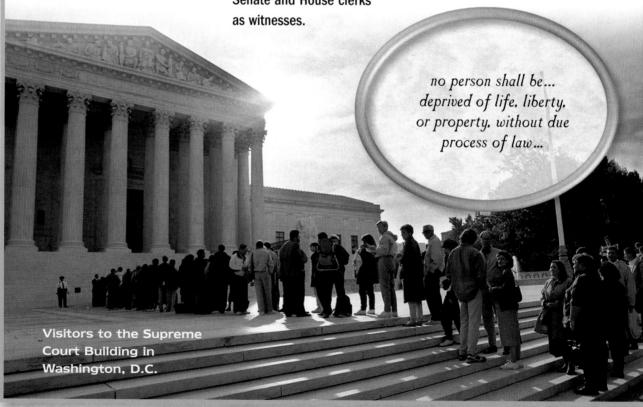

CONGRESS or THE United States, begun and held at the City of New York on Wednesday the Jourh of March, one thousand seven hundred and against a TILE Considers of a norther of the Main, having at the time of their adopting the Constitution, rescribed a detree, in order to present our probability to a detree, in order to present our probability to a detail the control of the properties of the Springer and the formal the breefing with the state of the second of the s RESOLVED be the South and House of Representations of the Months of Source in Congress growther has these of the Months of the Source of the Months of the Source of the Months of the Source of the S . ARTICLES or willben to and de of the several Mates . pursuant to the fifth thitale of the Oliganat Constitution Lettels the prot ... Up the first enumention regimes by the first recite of the Constitution, then shall be one Representation for very thirt, the words with the enumer shall recovered by the first recite of the Constitution for very thirty the words with the enumer shall recovered by the first recite of the Constitution of which the projection shall be a right of knights. That then shall be not left than one hundred Representations, were left than one Representative freieng full thousand name until the member of Regres white a superfection and to be handred , show such the projection shall be so rigulated by Congress that there went not be of their two one Regeneralative for very physicism of persons Thele the second. We have verying the congruention of a water office handers and degree deliver shall take office and in a deliver of hypermetrics shall have been remarked to the letter of the property of t I and to petion the Granical the dark is of granamen While the fourth and regulated within , being weeping below wants of he State the right of the people to hope and bear times shall set be infringed. gurilland the my house, really with the council of the course, nor in time of wary but in a marine to be presented by four the While the rolling the right of the pople to be seen with grown bries paper and office organis normalle sentent was severe short not be redstal, and in thousand wall for some of the that by talk or a formalism and productarly describing the place to be searched, and the prosons or chings to be expected er to a complex probleming superior server, and to one persentenced orientetuned of figures pay compet in early covering on the two White who moulded serve in line of the a fall danger no shall my power to subject to the same officer to be live put in page by of the a links we had been puted many inal tower lake a certain regard hierary mark deprised of life the late, or properly without due freein of lower constant property to take the public naive without In all country proceeding the second is all emports up to second and public head, by as imported jung of the second second seconds winds some bree. which the eight between shall have been previously never legal by lover, and to be informed of the nature and come of the accountions; here on freedy with the inchesper against home to been togething plans ing little fir in his jour, and is find the agustines of terrised fresher defeated Willell Me 118 16 . In such strong may land while the californ conference with weath went light of title by jung shall be programed and we for third one jung shall be illustrated in some White Me lall " Croper hard shalland to required our except fine import, not coul and unwest presidented inflated Article the eleventh rounded in the Court atom, with an rights, shall not be construed to day or disparage others relatively sight may be The power and obligated to the United Hore bythe Condition on successful by a later Make one toward to the Make a production of the Make and the Make a production of the Make a production of the Make and the Make a production of the Make and the Make a production of the Make and the trick the livelith. Medianing Speaker of the House of Sugarson . Irrasn John Albans, Via Praidert oft Matal States and South of the South From Buthfug 14 2 Hilliam 19

Religion, speech, the press, assembly, and petition—these freedoms are guaranteed in the First Amendment.

Freedom of Religion

A t the time of the colonies, most countries had an official religion. People who belonged to other religions were often persecuted, or not treated fairly. The Puritans came to America to escape this persecution. Then they turned around and did the same thing.

Anne Hutchinson preaching in Massachusetts

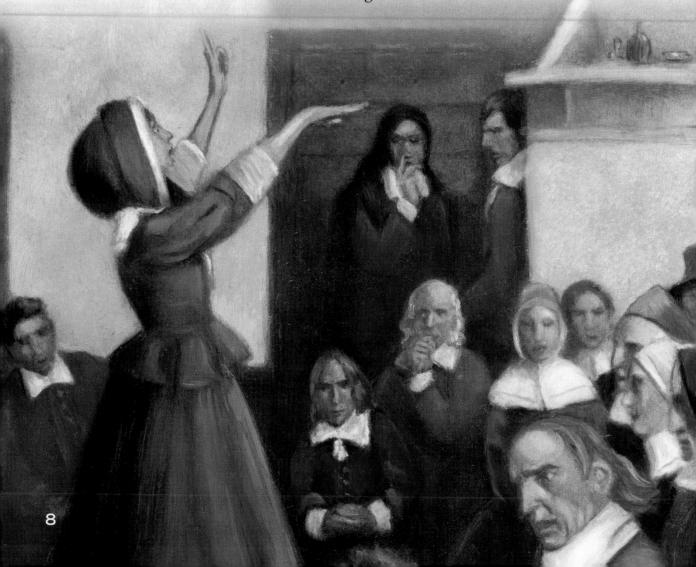

One Puritan woman in the Massachusetts Bay Colony disagreed with the leaders. Anne Hutchinson held religious meetings in her home instead of the church. She told people that they could speak to God themselves. They didn't need ministers to do it for them. The leaders of the colony were furious. In 1637, they arrested Hutchinson, tried her, and threw her out of the colony.

Things were not so different 150 years later. People in Virginia were getting ready to approve the Constitution. There, the Church of England was the official religion. Baptists were persecuted. Some Baptist ministers had been publicly whipped and jailed for preaching. One, Reverend John Leland, told James Madison about it. Madison, the "father of the Constitution," was shocked. Now he understood why the Bill of Rights was needed. After the Constitution was ratified in 1788, he led Congress to add it.

It begins with freedom of religion. The First Amendment guarantees us two kinds of religious freedom:

- We are free from any official religion.
- We are free to practice any religion—or none at all.

What sorts of activities could make a religion "established"? Our courts decide. Can public school sporting events begin with a prayer? The courts say "no." Government buildings and government-run schools—that is, public schools—can't sponsor religious activities. If they did, they would be establishing religion.

"Congress shall make no law regarding the establishment of religion"

This is how the First Amendment begins. There is no "established," or official, religion in the United States. And Congress cannot "prohibit the free exercise" of religion.

James Madison

The main writer of the Constitution was a gracious, charming lawyer from Virginia. He had helped to write that state's constitution. He was also an author of *The Federalist*. This series of articles helped persuade Americans to vote for the Constitution.

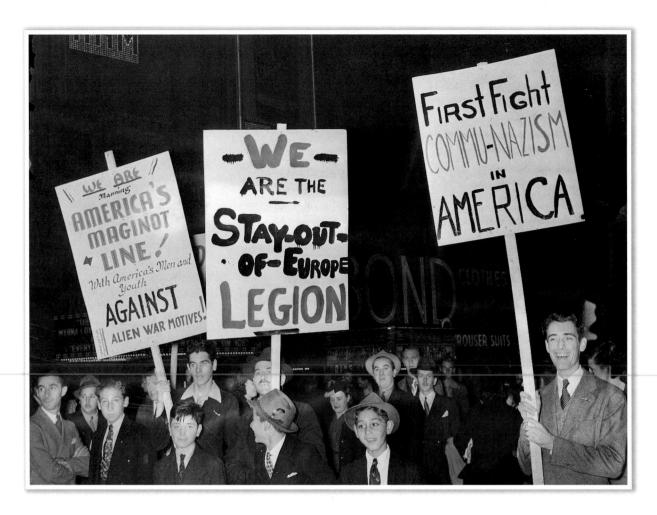

A protest in 1939 by Americans opposed to U.S. involvement in World War II

Freedom of Speech

In a free society, people are able to talk about what is happening. They discuss issues and make their own decisions. They can criticize their leaders. They can share their ideas.

Free speech is important to everyday life. We often take it for granted. Imagine having ideas you could not share. In many places in the world, this is what happens.

Talking is not the only thing protected by free speech. The courts have ruled that speech includes art, music, activities—even clothing. You can wear t-shirts with slogans or sing songs about how you feel. These are ways to express opinions and ideas. The First Amendment protects freedom of expression.

The First Amendment protects only speech and expression that does not cause a "clear and present danger." You cannot encourage people to commit a crime or to riot. For example, yelling "fire" in a crowded building as a joke would be a crime.

When the Bill of Rights was written, people could communicate with one another only in person or by letter. Today, we have the Internet. This technology has raised new issues about freedom of expression. Some people spread messages from terrorists and hate groups. Some people use the Internet to make plans for unlawful activities. Lawmakers are concerned about these uses of the Internet. Can they pass laws to stop certain activities? They must be careful. Laws can prevent crimes, but they cannot stop free expression.

Ideas are powerful. Some people's ideas make other people angry. Jokes about people's race or nationality are cruel. Plays and paintings that mock heroes or religious leaders make some people furious. However, the First Amendment protects these expressions. Speech is not illegal just because it is cruel, unpopular, or upsetting. We have to put up with some bad ideas in order to be sure we get the good ones. This is part of being free.

"abridging the freedom of speech"

The First Amendment uses abridging to mean "limiting" or "reducing." Congress cannot pass any law that weakens the right of free speech.

Environmentalists exercising freedom of expression in 1987 at the Lincoln Memorial in Washington, D.C.

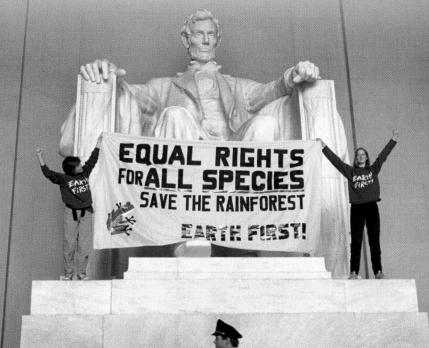

Freedom of the Press

The press are the people who make information available to others. In colonial times, the press largely produced newspapers. Colonial lawmakers sometimes tried to control the press when newspapers criticized public officials.

In the mid-1730s, colonist John Peter Zenger published many articles that criticized New York's royal governor. They were printed in his newspaper, the *New York Weekly*. The governor got fed up with Zenger and had him charged with unfairly damaging his reputation.

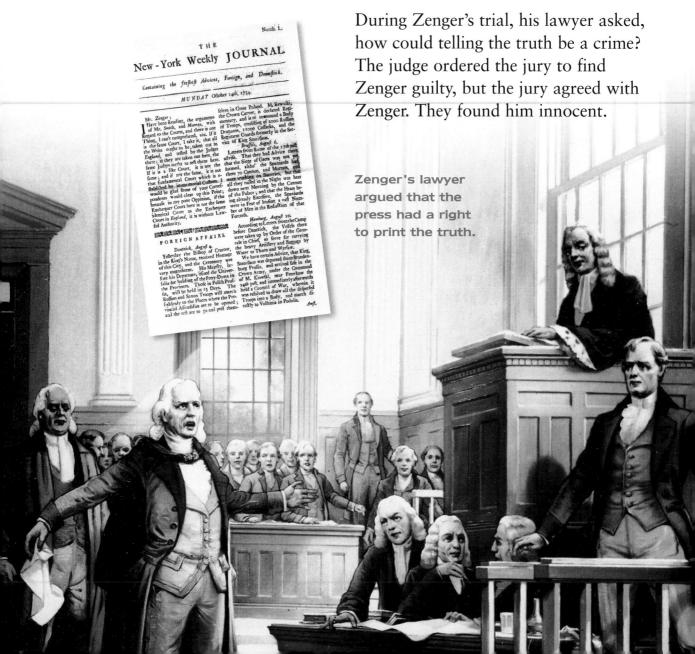

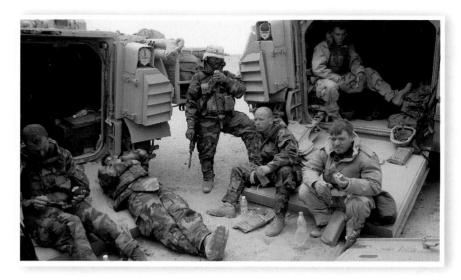

Allowing reporters (such as the man lower right) to travel with U.S. military units during the 2003 Iraq war raised fears of government control of the news.

Today, in addition to newspapers, the press includes the people who produce magazines, radio, TV, and even Internet sites—all the media. Freedom of the press protects their right to express their opinions and ideas in writing. We are a democracy. We elect our leaders and our lawmakers. Writers must be free to publish what they find.

Freedom of the press has brought about great changes in this country. Thomas Paine published his pamphlet *Common Sense* just before the American Revolution. It convinced many colonists of the need to declare America's independence from Britain. Between October 1787 and May 1788, a series of essays called *The Federalist* appeared in several New York newspapers. These essays persuaded New Yorkers to approve the U.S. Constitution. In the early 1850s, a book called *Uncle Tom's Cabin* caused many Americans to oppose slavery. Between 1972 and 1974, a series of articles in the *Washington Post* reported on unlawful acts committed by President Richard Nixon and helped force him to resign.

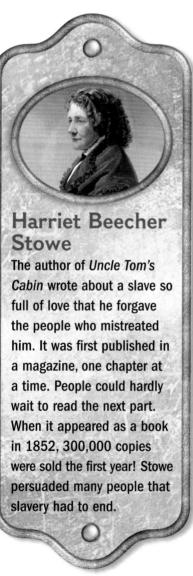

"the right of people peaceably to assemble"

The First Amendment gives people the right to have peaceful meetings. Riots are not peaceable. When a meeting turns into a mob, our laws give police the right to break it up.

Right to Assemble

The right to assemble is necessary to free speech. It allows people to get together to discuss ideas or to make their complaints known. That is, they have the right to protest.

Before the American Revolution, British troops broke up groups of people talking on the street. British governors banned town meetings. The British assumed that the colonists could not plan a revolt if they could not talk about it. The colonists who planned the Revolution had to meet in secret. When it came time to build a new government after the Revolution, people remembered the importance of the right of assembly.

The First Amendment guarantees that people can meet to talk about their ideas. They have the right to try to change the opinions of others through peaceful demonstrations. During the 1950s and 1960s, Dr. Martin Luther King, Jr., and others marched against racial prejudice and discrimination. Their actions got the government to pass laws that made racial discrimination illegal in many areas of American life.

Martin Luther King, Jr.

Hundreds of thousands of people gathered in Washington, D.C., to hear Dr. King give his famous "I Have a Dream" speech. In gathering together, they were showing support for a message that was changing America. They were making use of their right to assemble.

The right to assemble covers everything from marching in a Fourth of July parade, belonging to a political party, or joining an Internet chat group. You have a right to join groups, and the groups have a right to meet.

When people assemble, they are not allowed to block streets or to create traffic jams. They cannot march across private property. They cannot chain themselves in the doorway of a public building to keep people from entering. Carrying a picket sign is legal, but stopping workers from getting to their jobs is not.

People in Washington, D.C., come together to try to influence U.S. foreign policy.

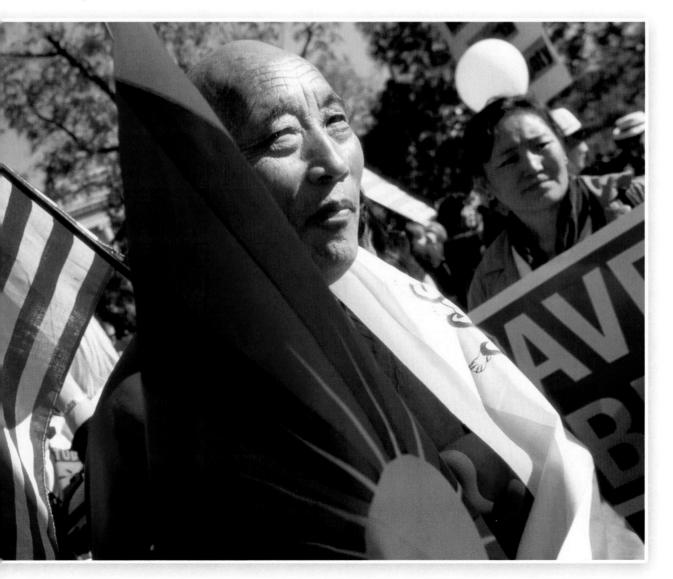

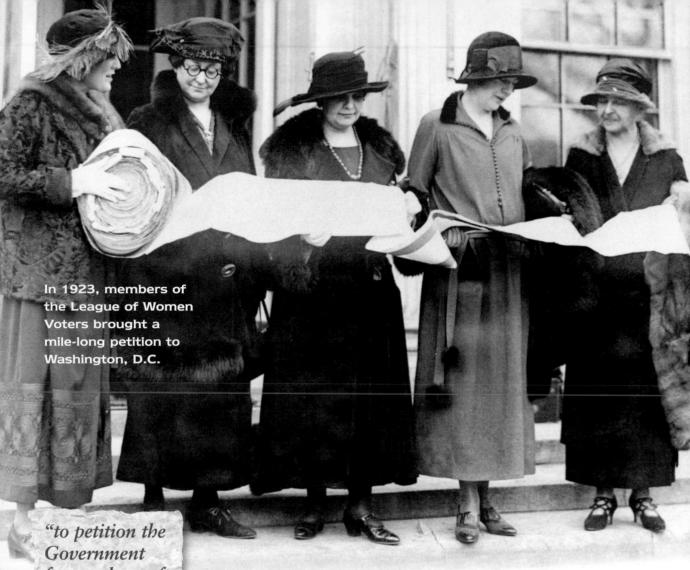

for a redress of grievances"

Redress means "to set right." Grievances are the wrongs or complaints that the people have. When this phrase was written, people wanted to be certain they could ask the government to do the right thing for them without being punished.

Right to Petition

What happens when people don't like what their government does? How can they get the government to change? Before the Revolution, representatives of the colonies sent Britain's King George many respectful letters. These letters, or petitions, explained that the king's policies took away the colonists' rights. The petitions politely asked the king to fix their problems. The king ignored the colonists' petitions and called them traitors.

The First Amendment protects the right to ask our leaders to stop doing things we believe are wrong. We cannot be put in jail for making such suggestions.

The right to petition is also used to ask government for things. People might ask lawmakers to pass a law, change a law, or cancel a law. People have sent petitions to the government in Washington, D.C., asking for laws to protect air and water quality. People have petitioned their state government to lower their taxes. In some states, voters have asked their state lawmakers to ban the use of cell phones in cars. A town government might get petitions to put a stop sign at a dangerous corner. You might petition your city government to build a swimming pool.

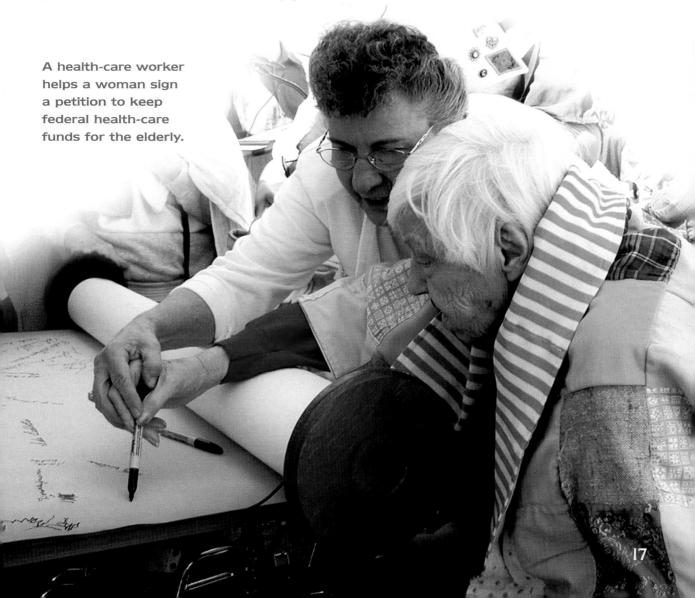

The colonists' homes, in British tradition, were safe, even from the king. The Second, Third, and Fourth Amendments extend this protection to American homes and communities.

Second Amendment

Do you remember when Paul Revere called the villagers and farmers out to fight? He rode out on horseback shouting, "The British are coming!" The minutemen who answered his call were a militia. They were armed to protect their communities.

Soldiers in a National Guard unit are a militia.

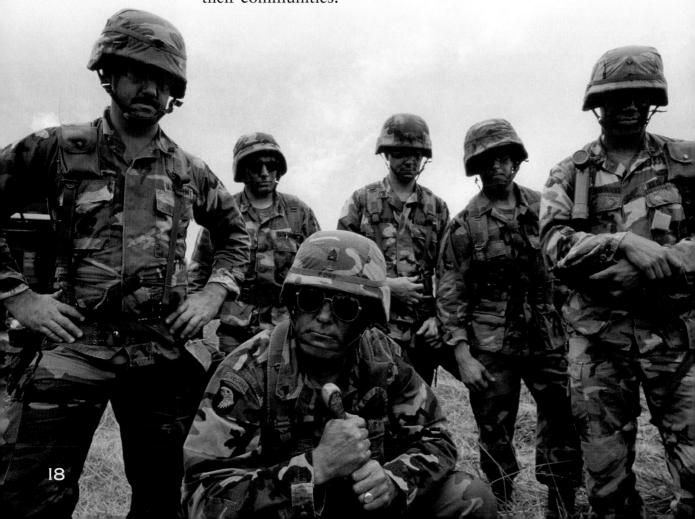

Paul Revere

This famous revolutionary was also a printer and an artist. His best known picture shows British soldiers shooting at a crowd of colonists. He called the incident "the Boston Massacre." It helped make other colonists want to fight against the British.

A militia is an army of part-time soldiers who are ready to protect their fellow citizens in time of emergencies. Each colony had a militia. These citizen-soldiers helped defend their communities. They helped to preserve law and order. Today, the state police and the National Guard do the work of the early militias.

The Second Amendment says the national government can not keep a state from having guns and other weapons. Many Americans believe that the "right to keep and bear arms" also gives every citizen the right to own guns.

People use guns to hunt and for target practice. Some people have gun collections. However, lawmakers have put limits on gun ownership to keep communities safe. In most cities, people have to get a permit to own a gun. Certain kinds of guns are not legal. People convicted of a crime can not own a gun. The courts have agreed these laws do not go against the Second Amendment.

Third Amendment

This amendment says that, in peacetime, the government can not make people give housing to soldiers. Does that sound odd? Well, the British had forced some colonists to let British soldiers live in their homes. In some ways, the Third Amendment is the most successful. Congress has never tried to put soldiers in civilians' homes.

"a well-regulated militia being necessary"

The Second Amendment begins with these words. The men who wrote the Bill of Rights gave this reason for the guarantee that "the right of the people to keep and bear arms shall not be infringed."

"The right of the people to be secure in their persons, houses, papers, and effects"

The Fourth Amendment is very specific. It protects individuals physically (their persons), their homes, their diaries and journals and letters, and all their personal property (their effects).

The Fourth Amendment

Many people say the Fourth Amendment protects "the right to privacy." That is because it says police or other government officials cannot search people or their homes unless there is a good reason to believe they have committed a crime. The government cannot snoop around in your business just in case you are doing something wrong.

Sometimes, the right to privacy is less important than other issues. Parents, teachers, and other school officials have the duty to protect children. They have the right to search children's rooms and lockers.

The men who wrote the Bill of Rights could not have imagined the kinds of searches possible today. Your "papers" include your telephone calls, e-mail files, and the history of Internet sites visited. There are records of the books you have checked out of libraries and the videos you have rented.

There are your doctor's records about you. There are your school records. It is hard to do anything today that does not leave a record! The Fourth Amendment protects against any unreasonable government searches of your records.

The courts have given school officials the right to search students' lockers.

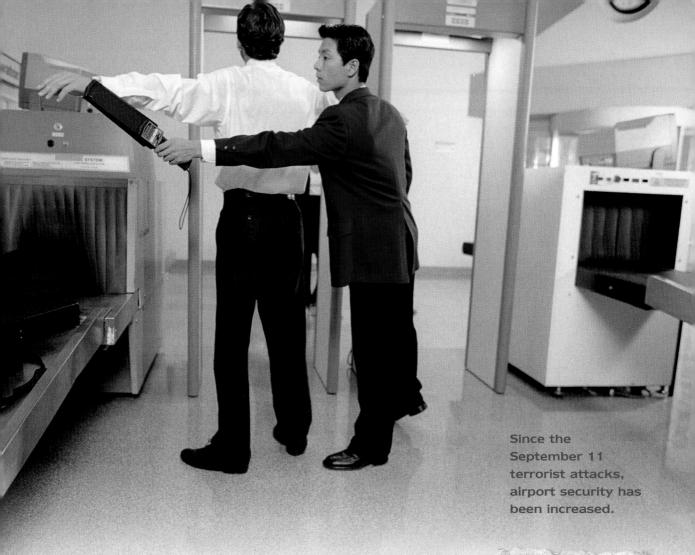

The Bill of Rights protects individual rights. There are times when the safety of a group is more important than the privacy of an individual. For example, the terrorist attack on September 11, 2001, caused many people to want the government to look hard for terrorists. People expect to be searched before getting on an airplane. Since the government can track Internet sites, should they investigate people who visit the ones that tell how to make bombs?

Questions like this end up in Congress and often in the courts. The answer is not as simple as it seems. People worry that giving up some rights can lead to losing many more rights. Remember, experience with a harsh government is the reason the Bill of Rights was written.

"unreasonable searches and seizures"

For a search to be "reasonable" there has to be "probable cause." There needs to be a good reason. A judge needs to agree that it is likely that evidence of a crime would probably be found in the search.

Rights of the Accused

Innocent until proven guilty—that idea is the cornerstone of our legal system. The Fifth, Sixth, and Seventh Amendments protect the rights of people accused of a crime.

double jeopardy

Anyone who goes to trial and is found innocent can't be tried a second time for the same crime. You cannot be put in jeopardy (in harm's way) twice for the same offense.

Fifth Amendment

This amendment guarantees that the government has to go through proper steps to decide if a person is guilty and should be punished. Many rules exist now about what is and what is not allowed as evidence in a trial. They are meant to help the court find the truth.

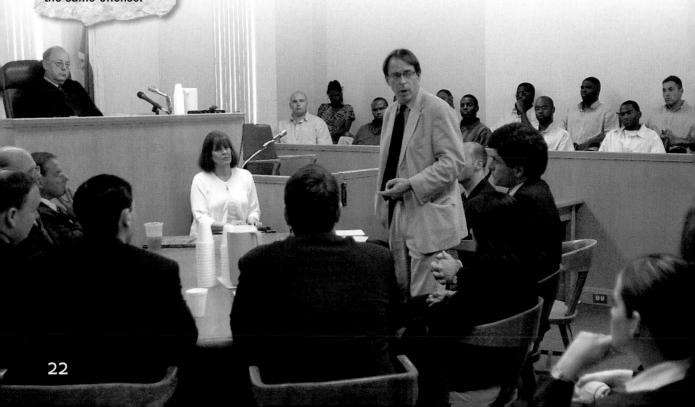

Here is what the Fifth Amendment says:

- If the crime you are charged with carries a death penalty, a grand jury must agree there is enough evidence to hold a trial.
- If you have been found innocent of a crime, you cannot be tried for it again.
- You cannot be forced to **testify**, give evidence, against yourself. Have you ever heard of people "taking the fifth"? That means they are refusing to answer questions in court because the answers might make them appear guilty, even if they are really innocent.
- You cannot be punished, or "deprived of life, liberty, or property," without due process of law.

The Miranda Warning

In 1963, a man named Ernesto Miranda was arrested for kidnapping. When the police questioned him, Miranda admitted to the crime. Later in court, his lawyer argued that Miranda did not fully know his rights. Now, police read the "Miranda Warning" to every person they arrest. "You have the right to remain silent...." The warning also

says, "You have a right to have an attorney present during questioning." If a person cannot afford a lawyer, then the court will pay for one.

> Anyone arrested for a crime in the United States is given the Miranda

Warning.

"No person shall be... deprived of life, liberty, or property without due process of law."

Due process refers to the "proper steps" set out in our laws for criminal matters. All the steps—arresting, questioning, accusing, holding a trial, and passing a sentence are part of the process. In each of those steps, there are protections for an accused person.

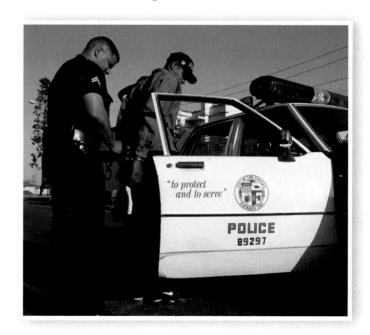

An accused person is tried by a jury of his peers.

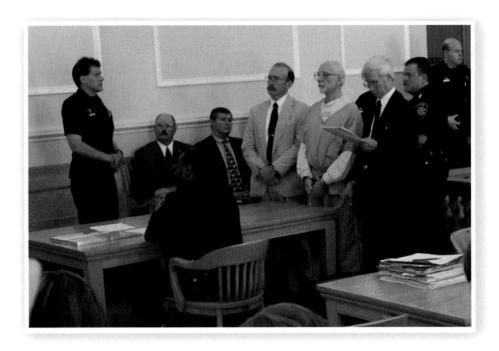

"an impartial jury"

When a jury is being chosen, the judge and lawyers on both sides ask the people questions. They ask if they have heard about the case. They listen for things that might show a person has prejudices. They choose people who can ignore what they have read or heard and can make up their own minds.

Sixth Amendment

Imagine you have been arrested and thrown in jail. You do not know why. After months, you go to court. The "evidence" against you is all just rumors, and the judge has already decided you are guilty. You don't have a lawyer. You cannot ask any questions of the witnesses. This crime happened at the very time you were playing baseball. You cannot call your coach or teammates to come say where you were. What chance would you have?

The Sixth Amendment protects you from this happening. It guarantees that people charged with crimes will get:

- a speedy trial
- a public trial
- a jury of fair-minded people from the same state and area where the crime happened
- the knowledge of the charges against them
- the right to see who is testifying against them and have their lawyers question those people

It may not seem as if trials are speedy. It takes time for both sides to prepare their case. The police must search for evidence. Witnesses must be found. The lawyers need to do research into decisions in other trials that were similar. There are many cases for the court to hear. A trial might not take place for months or longer, even after everyone is ready.

Television did not exist when the Bill of Rights was written. Should trials be on TV? Some people say that television helps the public know what is going on. Others say that TV cameras turn a courtroom trial into a "three-ring circus." They say that lawyers and witnesses act dramatic and take too long because they are "on TV." State legislatures could decide this. If they do not, judges are the boss in their courtrooms. They can decide whether or not to allow TV cameras.

WATER TO

Americans are still debating whether trials should be televised. Hugo Black

In 1963, the Supreme Court heard a case about a man named Clarence Gideon. He was too poor to get a lawyer for his criminal trial. The trial judge would not pay for one, and Gideon was found guilty. Justice Black wrote the Supreme Court's decision. He said it seemed "obvious" that you could not have a fair trial if you were not represented by a lawyer.

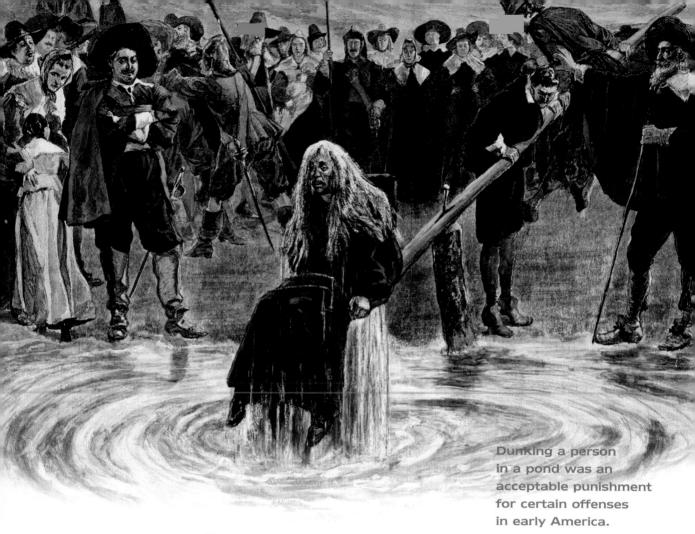

"excessive bail shall not be required"

Unless they are dangerous, people accused of crimes do not have to stay in jail until their trial. The court gives them the chance to post bail. That means they pay a sum of money that will be returned when they show up for the trial.

Seventh Amendment

Not all court cases are about crimes. Some cases seek to solve disagreements about property or money. The Seventh Amendment says that people in these civil lawsuits have a right to a jury trial if the amount is \$20 or more. Back when this was written, \$20 was equal to about 40 days of pay. Today, you would not ask for a jury trial over something worth only \$20.

Eighth Amendment

The Eighth Amendment says that the punishment should fit the crime. Punishment cannot be "excessive." A judge cannot send a person to prison for life for ten parking tickets. A judge cannot fine someone \$100,000 for not having a valid driver's license. Those punishments don't fit the crimes.

Punishments cannot be "cruel and unusual." The Bill of Rights does not let a judge invent bizarre punishments. Guilty criminals deserve to be punished. Society as a whole must agree that the punishment is normal and expected.

Today, many people believe that the death penalty is a cruel and unusual punishment. Almost all democracies have outlawed it. Only a few still use it. In the United States, people debate this point. If an innocent person is executed for a crime, there is not any way to fix it. You will certainly hear a lot more about this subject in your lifetime.

"cruel and unusual punishment"

Different societies have very different ideas about what is an acceptable punishment. In some countries, a person can have a hand cut off for stealing! In the United States, such a punishment would be seen as cruel and unusual.

Supporters of the death penalty hold a candlelight vigil for the victims of terrorist Timothy McVeigh on the day of his execution in 2001.

Limits to Power

The Bill of Rights protects individuals. It is a document that limits the power of the federal government. These last two amendments make that clear.

Ninth Amendment

Do people have any rights other than those in the Bill of Rights? The Ninth Amendment says "yes." Just because a right is not named does not mean it does not exist. It should "not be construed"—not be taken to mean—that other rights of individuals are not real or are not important.

The Ninth Amendment does not give the courts help in deciding what other rights people have. Judges have to use their training.

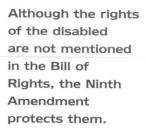

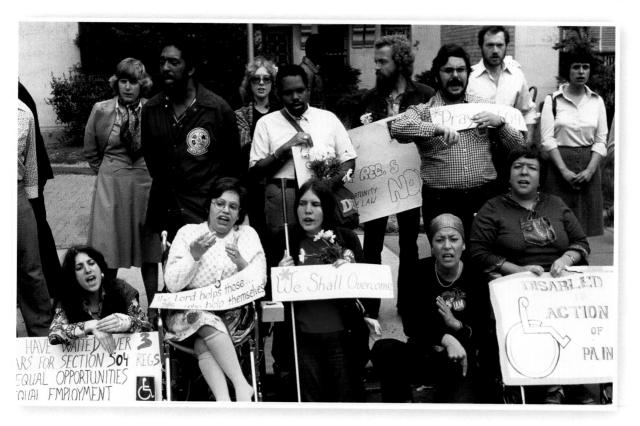

They look at how society is changing. Other amendments may help them decide. For example, the Fourth Amendment has encouraged courts to rule that people have the right to do what they want in private, as long as they do not harm anyone.

The courts have agreed we also have the right to:

- travel throughout America and outside the country
- get married
- raise and educate children as we want to

In addition the courts are clarifying the right to:

- an education
- a job
- housing

Tenth Amendment

The Tenth Amendment guarantees that the national government has only the powers that the Constitution gives it, and nothing more. This Amendment keeps the government and the people in balance. The United States government cannot take on more powers than it gets from the Constitution. All other powers belong either to the state governments or to the people.

The Ninth
Amendment
supports the right
of Americans to
travel freely,

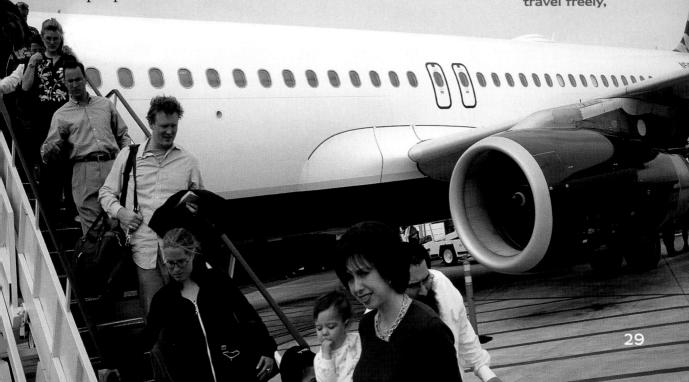

The Test of Time

People insisted that the Constitution include a bill of rights to protect individual rights. Their love of freedom has become part of what we Americans call our heritage.

The Founders of our nation would be amazed at how life in the United States has changed. Yet, what is really amazing is that the Constitution and Bill of Rights grew and changed with the times. Millions of people have come to America to share in the life of freedom these documents helped create.

Every year, new citizens are sworn in as people come to the United States for the freedoms protected in our Bill of Rights.

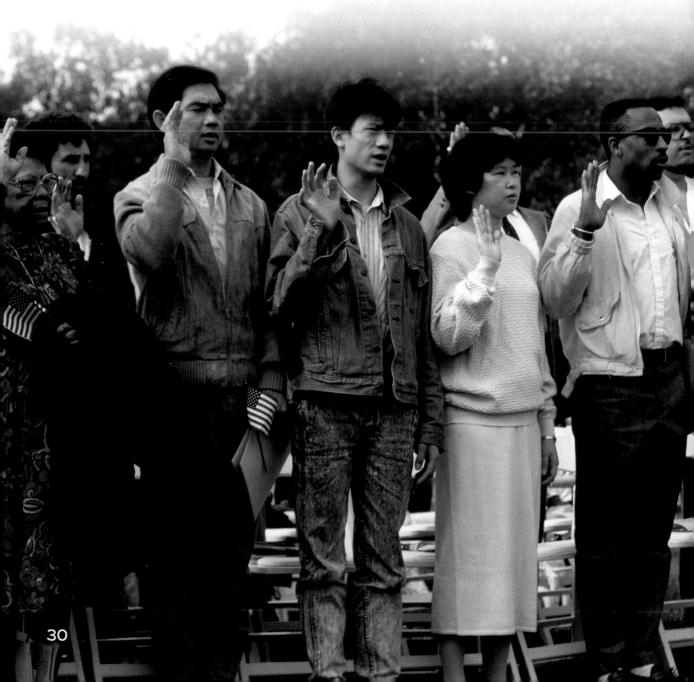

Glossary

amendment a legally adopted change to a law or a body of laws

assemble to come together in a group

Bill of Rights the first ten amendments to the U.S. Constitution. A bill of rights is a formal statement of the rights and freedoms considered essential to a group of people.

civil lawsuit a court case about money or property, not about a crime

discrimination treating people unfairly and differently because they belong to a group, such as a race or a religion

express to make things known, to communicate in some way

media TV, radio, newspapers, magazines, and other mass communication

militia an army of citizens called out in time of emergency

persecute to harass or harm, especially because of religion, politics, or race

petition a formal written document asking for a right or a benefit from an authority, such as a government

Norman Rockwell's famous World War II poster reminded Americans they were fighting to protect their freedoms. **prejudice** hatred of a particular race, religion, or group

press the people who make information available to others through newspapers, magazines, TV, radio, or other public media

Puritans members of a religious group in Britain and in the British colonies who followed a strict moral code ratify to approve and make official testify to give facts or state the truth under oath in court

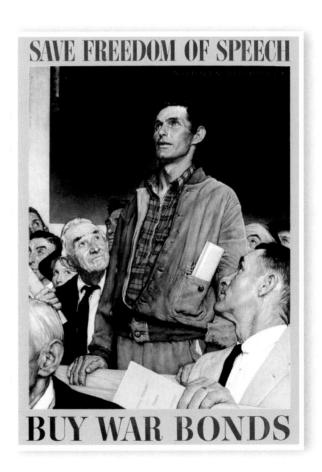

The Bill of Rights

Amendments I - X from The Constitution of the United States Ratified December 15, 1791

Amendment I

Congress shall make no law respecting an establishment of religion, or prohibiting the free exercise thereof; or abridging the freedom of speech, or of the press; or the right of the people peaceably to assemble, and to petition the Government for a redress of grievances.

Amendment II

A well regulated Militia, being necessary to the security of a free State, the right of the people to keep and bear Arms, shall not be infringed.

Amendment III

No Soldier shall, in time of peace be quartered in any house, without the consent of the Owner, nor in time of war, but in a manner to be prescribed by law.

Amendment IV

The right of the people to be secure in their persons, houses, papers, and effects, against unreasonable searches and seizures, shall not be violated, and no Warrants shall issue, but upon probable cause, supported by Oath or affirmation, and particularly describing the place to be searched, and the persons or things to be seized.

Amendment V

No person shall be held to answer for a capital, or otherwise infamous crime, unless on a presentment or indictment of a Grand Jury, except in cases arising in the land or naval forces, or in the Militia, when in actual service in time of War or public danger; nor shall any person be subject for the same offence to be twice put in jeopardy of life or limb; nor shall be compelled in any criminal case to be a witness against himself, nor be deprived of life, liberty, or property, without due process of law; nor shall private property be taken for public use, without just compensation.

Amendment VI

In all criminal prosecutions, the accused shall enjoy the right to a speedy and public trial, by an impartial jury of the State and district wherein the crime shall have been committed, which district shall have been previously ascertained by law, and to be informed of the nature and cause of the accusation; to be confronted with the witnesses against him; to have compulsory process for obtaining witnesses in his favor, and to have the Assistance of Counsel for his defence.

Amendment VII

In suits at common law, where the value in controversy shall exceed twenty dollars, the right of trial by jury shall be preserved, and no fact tried by a jury, shall be otherwise reexamined in any Court of the United States, than according to the rules of the common law.

Amendment VIII

Excessive bail shall not be required, nor excessive fines imposed, nor cruel and unusual punishments inflicted.

Amendment IX

The enumeration in the Constitution, of certain rights, shall not be construed to deny or disparage others retained by the people.

Amendment X

The powers not delegated to the United States by the Constitution, nor prohibited by it to the States, are reserved to the States respectively, or to the people.

The Declaration of Rights of the Stamp Act Congress October 19, 1765

The "essential rights and liberties" listed by representatives at the Stamp Act Congress served as a precedent for the Bill of Rights that became part of the U.S. Constitution.

The members of this congress, sincerely devoted, with the warmest sentiments of affection and duty to His Majesty's person and government, inviolably attached to the present happy establishment of the Protestant succession, and with minds deeply impressed by a sense of the present and impending misfortunes of the British colonies on this continent; having considered as maturely as time would permit, the circumstances of said colonies, esteem it our indispensable duty to make the following declarations, of our humble opinions, respecting the most essential rights and liberties of the colonists, and of the grievances under which they labor, by reason of several late acts of Parliament.

- 1. That His Majesty's subjects in these colonies owe the same allegiance to the crown of Great Britain that is owing from his subjects born within the realm, and all due subordination to that august body, the Parliament of Great Britain.
- 2. That His Majesty's liege subjects in these colonies are entitled to all the inherent rights and privileges of his natural born subjects within the kingdom of Great Britain.
- 3. That it is inseparably essential to the freedom of a people, and the undoubted rights of Englishmen, that no taxes should be imposed on them, but with their own consent, given personally, or by their representatives.

- 4. That the people of these colonies are not, and from their local circumstances cannot be, represented in the House of Commons in Great Britain.
- 5. That the only representatives of the people of these colonies are persons chosen therein, by themselves; and that no taxes ever have been or can be constitutionally imposed on them but by their respective legislatures.
- 6. That all supplies to the crown, being free gifts of the people, it is unreasonable and inconsistent with the principles and spirit of the British constitution for the people of Great Britain to grant to His Majesty the property of the colonists.
- 7. That trial by jury is the inherent and invaluable right of every British subject in these colonies.
- 8. That the late act of Parliament entitled, "An act for granting and applying certain stamp duties, and other duties in the British colonies and plantations in America, etc.," by imposing taxes on the inhabitants of these colonies, and the said act, and several other acts, by extending the jurisdiction of the courts of admiralty beyond its ancient limits, have a manifest tendency to subvert the rights and liberties of the colonists.
- 9. That the duties imposed by several late acts of Parliament, from the peculiar circumstances of these colonies, will be extremely burthensome and grievous, and, from the scarcity of specie, the payment of them absolutely impracticable.

- 10. That as the profits of the trade of these colonies ultimately center in Great Britain, to pay for the manufactures which they are obliged to take from thence, they eventually contribute very largely to all supplies granted there to the crown.
- 11. That the restrictions imposed by several late acts of Parliament on the trade of these colonies will render them unable to purchase the manufactures of Great Britain.
- 12. That the increase, prosperity, and happiness of these colonies depend on the full and free enjoyment of their rights and liberties, and an intercourse, with Great Britain, mutually affectionate and advantageous.
- 13. That it is the right of the British subjects in these colonies to petition the king or either house of Parliament.

Lastly, that it is the indispensable duty of these colonies to the best of sovereigns, to the mother-country, and to themselves, to endeavor, by a loyal and dutiful address to His Majesty, and humble application to both houses of Parliament, to procure the repeal of the act for granting and applying certain stamp duties, of all clauses of any other acts of Parliament whereby the jurisdiction of the admiralty is extended as aforesaid, and of the other late acts for the restriction of the American commerce.

Source: The Constitution Society http://www.constitution.org/bcp/dor–sac.htm

The Virginia Declaration of Rights June 12, 1776

These rights, drafted by George Mason, were added to the Constitution of Virginia and became a model for the Bill of Rights in the U.S. Constitution.

I

That all men are by nature equally free and independent, and have certain inherent rights, of which, when they enter into a state of society, they cannot, by any compact, deprive or divest their posterity; namely, the enjoyment of life and liberty, with the means of acquiring and possessing property, and pursuing and obtaining happiness and safety.

II

That all power is vested in, and consequently derived from, the people; that magistrates are their trustees and servants, and at all times amenable to them.

III

That government is, or ought to be, instituted for the common benefit, protection, and security of the people, nation or community; of all the various modes and forms of government that is best, which is capable of producing the greatest degree of happiness and safety and is most effectually secured against the danger of maladministration; and that, whenever any government shall be found inadequate or contrary to these purposes, a majority of the community hath an indubitable, unalienable, and indefeasible right to reform, alter or abolish it, in such manner as shall be judged most conducive to the public weal.

IV

That no man, or set of men, are entitled to exclusive or separate emoluments or privileges from the community, but in consideration of public services; which, not being descendible, neither ought the offices of magistrate, legislator, or judge be hereditary.

V

That the legislative and executive powers of the state should be separate and distinct from the judicative; and, that the members of the two first may be restrained from oppression by feeling and participating the burthens of the people, they should, at fixed periods, be reduced to a private station, return into that body from which they were originally taken, and the vacancies be supplied by frequent, certain, and regular elections in which all, or any part of the former members, to be again eligible, or ineligible, as the laws shall direct.

VI

That elections of members to serve as representatives of the people in assembly ought to be free; and that all men, having sufficient evidence of permanent common interest with, and attachment to, the community have the right of suffrage and cannot be taxed or deprived of their property for public uses without their own consent or that of their representatives so elected, nor bound by any law to which they have not, in like manner, assented, for the public good.

VII

That all power of suspending laws, or the execution of laws, by any authority without consent of the representatives of the people is injurious to their rights and ought not to be exercised.

VIII

That in all capital or criminal prosecutions a man hath a right to demand the cause and nature of his accusation to be confronted with the accusers and witnesses, to call for evidence in his favor, and to a speedy trial by an impartial jury of his vicinage, without whose unanimous consent he cannot be found guilty, nor can he be compelled to give evidence against himself; that no man be deprived of his liberty except by the law of the land or the judgement of his peers.

IX

That excessive bail ought not to be required, nor excessive fines imposed; nor cruel and unusual punishments inflicted.

X

That general warrants, whereby any officer or messenger may be commanded to search suspected places without evidence of a fact committed, or to seize any person or persons not named, or whose offense is not particularly described and supported by evidence, are grievous and oppressive and ought not to be granted.

XI

That in controversies respecting property and in suits between man and man, the ancient trial by jury is preferable to any other and ought to be held sacred.

XII

That the freedom of the press is one of the greatest bulwarks of liberty and can never be restrained but by despotic governments.

XIII

That a well regulated militia, composed of the body of the people, trained to arms, is the proper, natural, and safe defense of a free state; that standing armies, in time of peace, should be avoided as dangerous to liberty; and that, in all cases, the military should be under strict subordination to, and be governed by, the civil power.

XIV

That the people have a right to uniform government; and therefore, that no government separate from, or independent of, the government of Virginia, ought to be erected or established within the limits thereof.

XV

That no free government, or the blessings of liberty, can be preserved to any people but by a firm adherence to justice, moderation, temperance, frugality, and virtue and by frequent recurrence to fundamental principles.

XVI

That religion, or the duty which we owe to our Creator and the manner of discharging it, can be directed by reason and conviction, not by force or violence; and therefore, all men are equally entitled to the free exercise of religion, according to the dictates of conscience; and that it is the mutual duty of all to practice Christian forbearance, love, and charity towards each other.

Source: The University of Oklahoma Law Center http://www.law.ou.edu/hist/vadeclar.html

Miranda Rights

Miranda v. Arizona 384 U.S. 436 (1966)

Before a law enforcement officer may question you regarding the possible commission of a crime, he or she must read you your Miranda Rights. He or she must also make sure that you understand them.

Warning of Rights

- 1. You have the right to remain silent and refuse to answer questions. Do you understand?
- 2. Anything you do say may be used against you in a court of law. Do you understand?
- 3. You have the right to consult an attorney before speaking to the police and to have an attorney present during questioning now or in the future. Do you understand?
- 4. If you cannot afford an attorney, one will be appointed for you before any questioning if you wish. Do you understand?
- 5. If you decide to answer questions now without an attorney present you will still have the right to stop answering at any time until you talk to an attorney. Do you understand?
- 6. Knowing and understanding your rights as I have explained them to you, are you willing to answer my questions without an attorney present?

Source: The U.S. Constitution Online http://www.usconstitution.net/miranda.html

Index	legal system 22–29
accused, rights of the 22-23	Leland, John 9
Adams, John 6	Madison, James 9
American Revolution 4, 14	militia 18-19, 31
bail 26	Miranda Warning 23
Black, Hugo 25	Ninth Amendment 28
civil lawsuits 26, 31	Nixon, President Richard 13
colony 8, 9	Paine, Thomas 13
Common Sense 13	petition 16–17, 31
Congress 6, 9, 10, 21	privacy 20-21, 29
Constitution, U.S. 4–5, 9, 30	property rights 19-20
death penalty 27	protest 14, 15
due process 23	Puritans 8–9
Eighth Amendment 26–27	ratify 5, 6, 31
The Federalist 13	Revere, Paul 18, 19
Fifth Amendment 22–23	search and seizure 20-21
First Amendment 8, 10–17	Second Amendment 18–19
Fourth Amendment 20–21, 29	Seventh Amendment 26
freedom	Sixth Amendment 24–25
of assembly 14–15, 31 of the press 12–13, 25, 31	Stowe, Harriet Beecher 13
of religion 8–9	Tenth Amendment 29
of speech 10–11	Third Amendment 19
government 4–5, 13, 16–17, 19, 20, 29	trial 22-23, 24-25
Hutchinson, Anne 8–9	Uncle Tom's Cabin 13
Internet 11, 15, 21	Zenger, John Peter 12
King, Jr., Martin Luther 14	